Learn to Paint

COLOUR MIXING

Judy Martin

HarperCollins*Publishers*

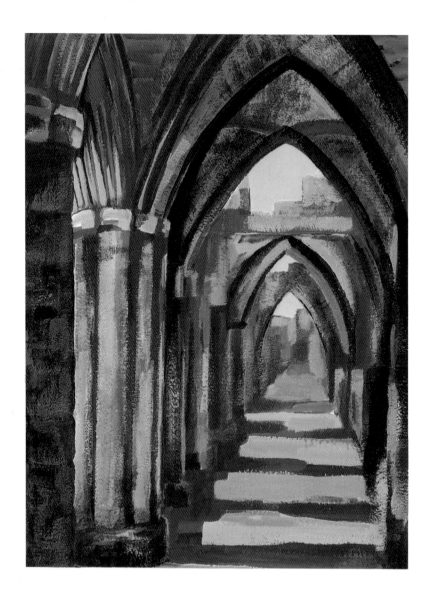

The author wishes to acknowledge
valuable assistance from Daler-Rowney
with special thanks to Jon Lloyd

First published in 1994 by
HarperCollins Publishers, London
Reprinted 1995

**A catalogue record for this book is available
from the British Library**

Editor: Nina Sharman
Art Editor: Caroline Hill
Designer: Amzie Viladot
Photographer: Nigel Cheffers-Heard

ISBN 0 00 412888 5

Produced by HarperCollins Hong Kong

FRONT COVER: Bandstand
122 cm × 137 cm (48 in × 54 in)

CONTENTS

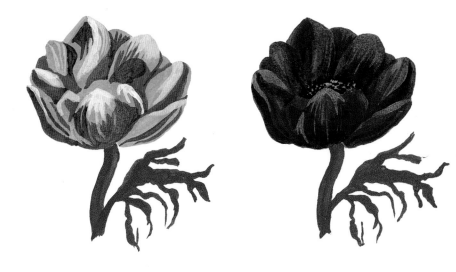

INTRODUCTION
Judy Martin

Mixing colours can be a specially enjoyable aspect of painting, a practical skill that enables you to immerse yourself in the physical properties of your paint medium, as well as helping you to make a successful interpretation of your subject. Unfortunately, it can also lead to error and frustration, when your palette becomes a sea of mud, expensive colours are wasted, and the exact colour mixture that might light up your painting eludes you.

Colour mixing is partly a skill that improves with experience. Every artist develops a palette of preferred colours and gets to know the mixtures they will make. But for inexperienced painters, colour mixing can seem quite an obstacle course. Relying solely on formulae for colour mixing can put you on the wrong track from the start. However, there are basic principles you can easily learn and understand about why some colours mix well together and others don't, or how to analyse the sort of mixture you are looking for and identify suitable component colours. It is important that you learn colour mixing through practice and, essentially, in relation to the particular subjects of your paintings, not in terms of general rules that you then apply equally to any picture.

Colour effects also depend on the kind of medium you are using – its texture and opacity – and the relationships between the colours once you have laid them on paper or canvas.

▲ *Judy Martin in her studio*

▶ Downs View Over
Acrylic on canvas,
84 × 84 cm (33 × 33 in)

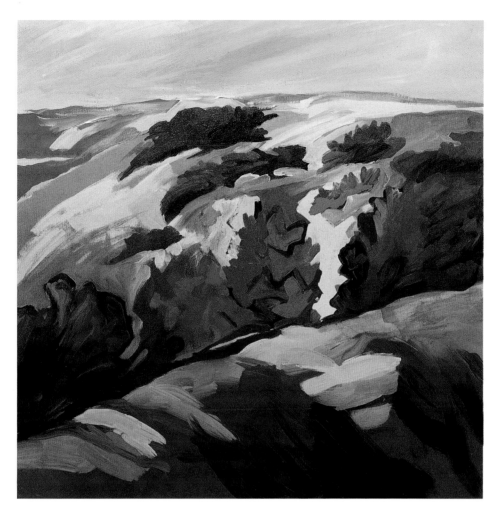

Keep in mind that colour mixing only solves one kind of visual problem that your painting sets for you. Getting the overall impression right involves other, separate skills, such as employing your painting techniques appropriately, and organizing your composition.

This book is a practical exploration of how colours work. It provides basic information about colour theory, the range of paint colours you can choose from, and the mixtures obtained with particular pairs or groups of colours. The principles set out in the beginning are then developed through application to a range of colour studies and finished paintings. The charts, colour samples and paintings throughout the book demonstrate actual, not theoretical effects. Colour mixing is placed firmly in the context of using colours in painting, with the additional intention of encouraging an adventurous approach and helping you to make the most of the exciting element of colour in your work.

ABOUT THE ARTIST

Judy Martin lives and works in Brighton, where the surrounding countryside has provided inspiration for a current series of paintings based on views of the Sussex Downs. She trained at Maidstone College of Art and Reading University, specializing in painting and printmaking, subsequently became a part-time art college lecturer, and eventually developed a career in publishing as a freelance writer and editor. Her practical art books include *Airbrush Painting Techniques*, *Drawing with Colour*, *Sketching*, *Pastels Masterclass*, *The Encyclopedia of Pastel Techniques*, and two other volumes in the same series on coloured pencil and printmaking techniques.

Colour is a vital element of her paintings, which are typically large-scale acrylics utilizing a bold, vibrant palette of strong hues and contrasting tones. Her work has been mainly abstract throughout her career, with a personal style of imagery often developed from natural sources such as animals and landscape.

HOW COLOURS WORK

▲ *This six-colour wheel shows the relationships of the primary colours – yellow, red, blue – and secondary colours – orange, violet, green.*

▲ *This twelve-colour wheel shows the intermediary hues yellow-orange, red-orange, red-violet, blue-violet, blue-green, yellow-green.*

Hue is the basic characteristic of a colour that identifies it individually, as red or blue, for instance. The colour wheel is a diagrammatic way of explaining how pure hues relate and interact. It reveals certain important principles that can help you to use colour more effectively in your paintings.

PRIMARY AND SECONDARY COLOURS

The simplest form of the colour wheel is based on three colours described as primary hues – red, yellow and blue. They are called primary because they cannot be mixed from other colours.

The primary colours are positioned on the wheel at equal distances apart, and in between them are the secondary colours – orange, green and purple – which represent a mixture of the two primaries on either side.

INTERMEDIARY HUES

If the wheel is divided again, it can include intermediary hues, shown here as red-orange, yellow-orange, yellow-green, blue-green, blue-purple, and red-purple. These appear between their component primary and secondary colours and represent a 'mid-way' mixture of the two hues. These sections could be further subdivided to produce a more subtle gradation of intermediary hues with increasing bias towards one or other of the components.

▲ *On any section of the wheel, the run of adjacent colours forms a harmonious relationship. This segment is subdivided to provide two intermediary hues between the primary and secondary colours.*

RELATED COLOURS

In any given section of the wheel, the run of adjacent colours forms a naturally harmonious progression, as in the band shown on page 6 running from yellow through five shades of orange to red. Although each of the primary colours is a pure hue quite unlike the others, they are directly related to each other by the intermediary 'mixed' hues. So although, for example, pure reds and blues make quite a strident combination, they can be unified in a painting by the addition of the intermediary red-purples and blue-purples that create the colour link.

COMPLEMENTARY COLOURS

Colours positioned directly opposite one another on the wheel are known as complementary pairs. Each primary colour has a complementary, which is the secondary colour composed of the other two primaries, that is, red/green, blue/orange, yellow/purple. The defining factor of the complementaries is that the two colours are as unlike as they can be – a pure green contains no red, and so on. They form particularly powerful contrasts and are described as 'mutually enhancing', appearing to intensify each other.

Complementaries that are evenly matched in intensity and brilliance, such as bright red and green or strong mid-blue paired with vivid orange, produce an optical effect in which the colours seem to flash and flicker against each other. This does not occur when there is a natural variation between light and dark colours.

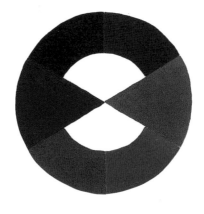

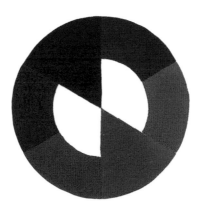

◄ The complementary colours are those that appear directly opposite each other on the wheel – red and green; blue and orange; yellow and violet.

▼ A strong hue tends to bring out the complementary aspect of a neighbouring colour. The grey squares here appear slightly different in colour bias, although all are painted with the same neutral black-and-white mix.

BASIC MIXES

When you mix colours that are alike or closely related, because of their similarity you obtain a clean intermediary hue. When you mix complementary colours, however, it is like mixing all three primaries and the combination of their different qualities forms a muddy, in-between colour. This can be useful when you want to mix neutral colours other than pure grey, but it is also the source of some of the typical problems encountered in colour mixing.

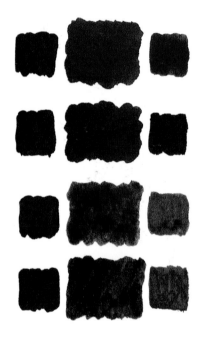

▲ *Similar hues produce clean intermediary colours, like the mixtures of Vermilion with Crimson Alizarin and Vermilion with Cadmium Orange. Opposite or unlike colours produce neutralized mixes, as with Vermilion and Hooker's Green or Cadmium Orange and Cobalt Blue. This is a useful basic principle of colour mixing that will help you to avoid making muddy colours where you want fresh-looking hues.*

CHARACTERISTICS OF PAINT COLOURS

The colour wheel is often taken to provide a formula for colour mixing, implying that all colours can be mixed from a basic palette of red, yellow and blue. But if you try to create a colour wheel, you will immediately encounter an important practical problem. You cannot buy tubes of paint labelled primary red, yellow or blue – these absolutely pure, unbiased, infinitely mixable colours occur only in theory, not in practice.

On a manufacturer's colour chart, you may have a choice of four or five 'true' reds and blues, and two or three 'true' yellows. In practical colour mixing, the particular pigments that you choose to form your primary hues subsequently influence the results of all your mixtures.

Most paint colours are not pure hues, but have a bias towards another colour. You can anticipate how basic mixtures will work by identifying the character of the paint colour and relating it to the appropriate segment of the colour wheel. Cadmium Red, for example, is an orange-red compared to Crimson Alizarin, which is a bluish red. Neither of these colours, then, accurately represents the concept of primary red. To be able to predict your colour mixes, you need to be aware of the bias of a particular colour and decide whether to mix it with a related or an opposite hue.

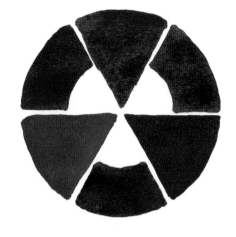

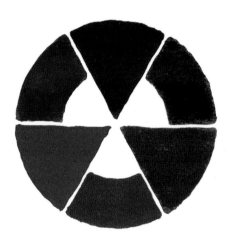

▲ *These two watercolour wheels show how the secondary colours that you mix depend on the primaries that you choose. On the first wheel, you have a reasonably rich purple made with Crimson Alizarin and Ultramarine, the orange is quite deep, and the green a muted shade. On the second wheel, the orange and green come up brighter, but the purple is brownish and dull. However you adjust the proportions of your two primaries, you will not get truer secondary mixes with the same colours, because these are their given qualities of hue.*

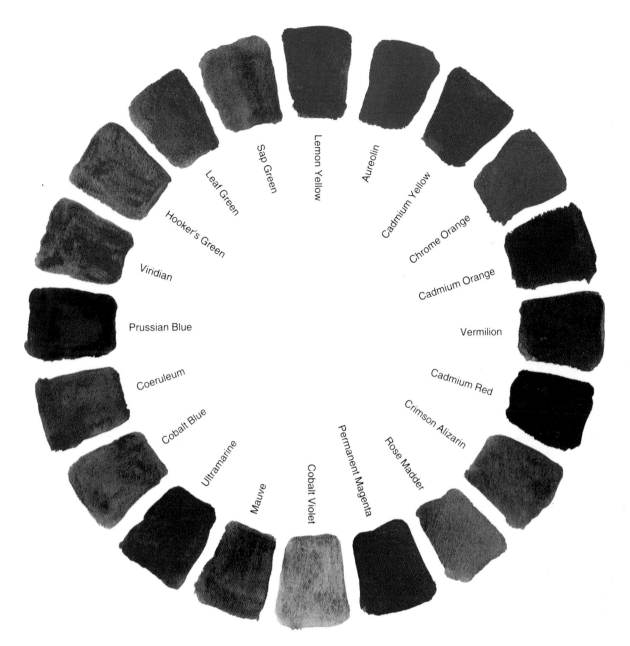

Sap Green
Lemon Yellow
Aureolin
Leaf Green
Cadmium Yellow
Hooker's Green
Chrome Orange
Viridian
Cadmium Orange
Prussian Blue
Vermilion
Coeruleum
Cadmium Red
Cobalt Blue
Crimson Alizarin
Ultramarine
Rose Madder
Mauve
Cobalt Violet
Permanent Magenta

▲ *With this arrangement of 20 watercolour hues in appropriate positions on a colour wheel, you can see that colour relationships in paint colours are more complex and variable than in the simple theoretical models of the colour wheel.*

A WHEEL OF PAINT COLOURS

The enlarged colour wheel shows twenty colours from the Daler-Rowney watercolour range ordered in terms of their relative colour bias; for example, positioning Cadmium Red as an orange-red, Crimson Alizarin as a bluish red tending towards red-purple, Ultramarine as a reddish blue, Coeruleum Blue as a greenish-blue, Viridian as a blue-green, Sap Green as yellow-green, and so on through yellow and orange back to red.

Now you can see that to mix a clean purple you need to mix a bluish red with a purple-blue. Choose Crimson Alizarin or Rose Madder, rather than Vermilion or Cadmium Red, which are orange-reds and complementary to blue that lead to the muddying of the mixture. The same applies to the blue that you choose – Ultramarine is close to the blue/purple area of the wheel, while Coeruleum is a greenish blue.

TONAL RANGE

Tone is the property of colours that measures their relative lightness and darkness. The basic concept of tones, or tonal range, corresponds to a grey-scale passing from white through successively darker greys to black. This can be interpreted in two ways in relation to paint colours.

Each colour has an inherent tone – for example, yellows are typically light in tone; bright blues, greens and reds occupy the middle of the tonal range; deep blues and greens, violet and purple are naturally dark-toned colours. You can also consider a particular colour in terms of a potential tonal range – for example, with red, this would be graded from pink tints through bright red to a deep-toned shade such as dark crimson or maroon.

VARYING TONAL VALUES

A given colour can be mixed with white to lighten it, with black to darken it. But as you can see from the colour chart (right), adding black tends to devalue the original hue, even producing an apparently separate colour – a bright red mixed with black appears brown, rather than dark red, and yellows darkened with black turn green. Black also has a deadening effect on strong colours, reducing their intensity.

Sometimes a more effective way of darkening paint colours is to mix or blend them with a

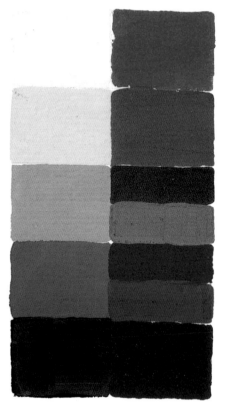

◀ No colour is as light as white or as dark as black, so on a grey-scale all the hues correspond to shades of grey in the light, middle or dark tonal ranges.

▼ The centre band of this chart represents pure colours, primaries and secondaries. Above, they are lightened with white in two stages; below, darkened with black. Notice how dull the colours appear when darkened with black, and how the hue can change, as where the bright yellow becomes an olivey green in the bottom band.

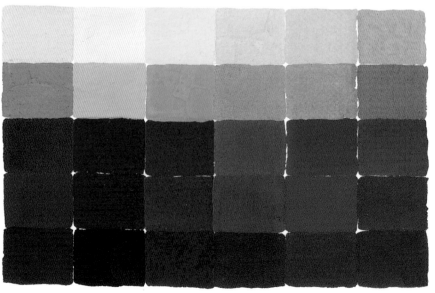

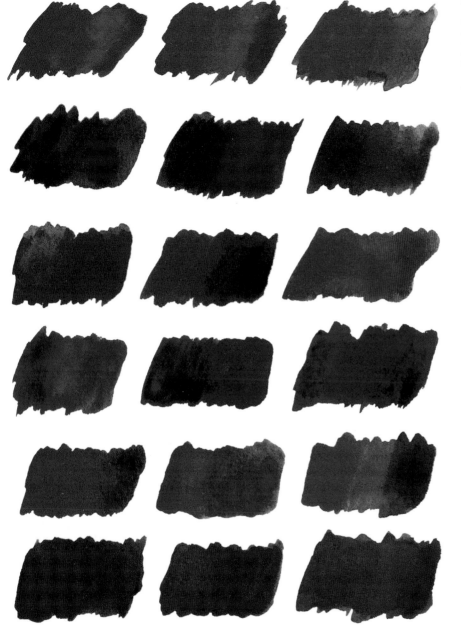

visually compatible and naturally darker hue. The chart on the left shows how this can work in practice, provided that you use a different paint colour representing the same basic hue, or a closely related colour. The addition of, for example, Prussian Blue or Mauve to mid-toned Cobalt Blue produces a darker blue that is richer and more colourful than a blue-black mixture.

COLOUR INTENSITY

Intensity, or saturation, is the third main property of colours, together with hue and tone. In terms of how you perceive a colour, it is the density and clarity of the hue. Loss of intensity is described as 'greying', and can be demonstrated by mixing a pure hue with grey. Black, white and grey are neutral colours, and adding them to another colour tends to neutralize the hue. The familiar 'muddying' that can occur when you mix two or more hues together is also due to loss of intensity – artists' pigments partially 'mask' each other when they mix, and the colour saturation of each hue is devalued.

▲ *An alternative way of shading a colour in your painting, rather than mixing it with black, is to gradate it into a deeper hue, either within the same colour family or a closely related colour.*

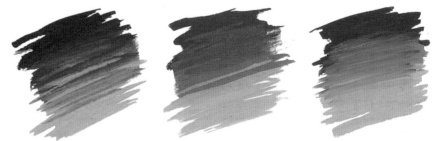

▲ *In the centre of these colour swatches, where the colours are shaded into neutral grey, you can still see the basic character of each hue, but its intensity is much devalued.*

WARM AND COOL COLOURS

The idea of colour 'temperature' in paint colours introduces another set of colour characteristics that can be used in forming harmonious and contrasting schemes in painting. The colour wheel again helps to explain the basic principles. Broadly, warm colours contain red or relate directly to the red/orange segments of the wheel. Cool colours contain blue and are based around the blue/green segments of the wheel.

USING WARM/COOL CONTRASTS

To some extent, this idea of colour temperature can be based on associations in the real world – red and orange as the colours of fire; yellow as strong, warm sunlight; blue as the colour of airy skies, and associated with water and ice. In painting, however, it is not necessarily used in this kind of symbolic way, although a hot, summery landscape can be suggested by giving the natural colours a cast of yellow and orange, while snow-scenes often contain blues and cold purples.

Warm/cool contrasts can also be used in creating the illusion of space and form in painting. Warm colours are said to be 'advancing' – they strike the eye and can take on a dominant role in an image, bringing certain elements of the picture closer to the viewer; whereas cool colours

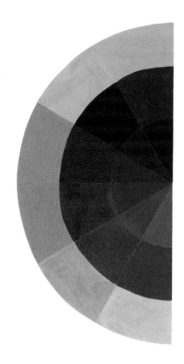

▲ *This half of the colour wheel goes from bright yellow through orange to red and red-purple. I have shown three degrees of tone in each section, making the light and dark tones by mixing the basic hue with white or black. Colours down the straight side of the half-wheel are borderline – very pale or dark values of yellow, for example, can appear cooler.*

are 'retreating' – they invoke space and distance, and can seem to draw parts of the picture away from you.

Warm colours also light up a painting, while cool colours invoke shadow. In this way, you can use the balance of warm and cool to create form and structure, either in association with tonal modelling or as a substitute for a notable contrast of tones.

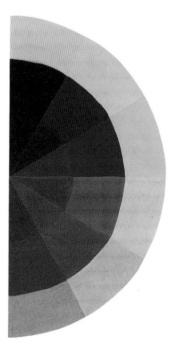

▲ *Yellow-green lies at one end of this half-wheel, and purple at the other. Purples are potentially quite variable in 'temperature' because they are composed of warm (red) and cool (blue) colour, and are responsive to the influence of other adjacent colours.*

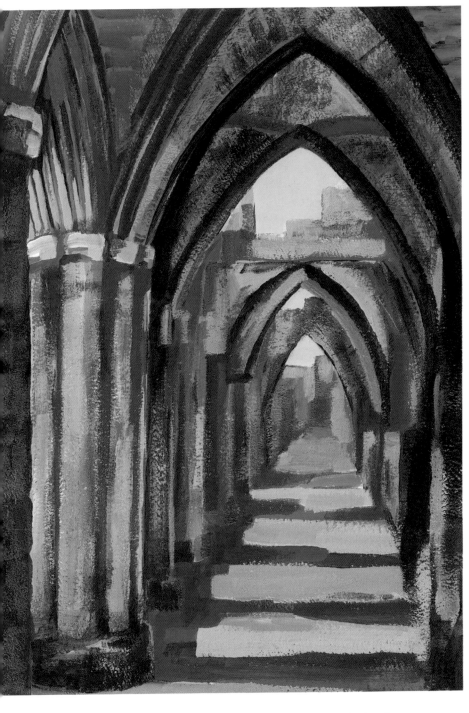

VARIABLE CHARACTER

While the interactions of warm and cool colours can play a useful role in organizing the balance and structure of a painting, applying these principles is not quite so straightforward. Observed properties of colour are relative: reds typically appear warmer than blues, but it is also possible to see one kind of red as relatively cool compared to another. This might be described as a blue-red rather than an orange-red; Crimson Alizarin as opposed to Vermilion. A clear, light yellow such as Lemon Yellow might appear relatively warm in relation to a cold blue, but it will appear cooler than a golden yellow like Cadmium Yellow.

Colour perception is partly subjective, and people may agree or disagree on such assessments. You can only try to make colours work in ways that look right to you, according to your own perception of their hue, tone, intensity and colour temperature.

PAINT COLOURS

Paint colours do not neatly correspond to the range of hues demonstrated by the theoretical colour wheel, because they derive from solid materials that can reliably impart their colours to paint with long-lasting effect. Pigments – the colouring ingredients in paint – come from natural and artificial sources; some have been established as artists' colours for centuries, others are quite newly developed synthetic colours. They include very strong or brilliant hues and muted, subtle shades.

The names of paint colours are not always derived from the pigments they contain, although this is often the case. But specific names help to provide a colour standard which should vary little between different media and brands of paint.

Lemon Yellow: Light-toned; greenish; cool

Naples Yellow: Light-toned and slightly chalky, reddish,

Aureolin: Light- to upper mid-toned, with less intensity than other yellows, greenish, cool

Vermilion: Mid-toned, intense orange-red, warm

Cadmium Red: Mid-toned, very intense with bias to orange-red, warm

Scarlet Lake: Mid-toned, intense rich red, warm

Permanent Magenta: Lower mid-toned, intense red-purple, warm

Cobalt Violet: Mid-toned with variable red/blue bias, may tend to warm or cool, depending on adjacent colours

Mauve: Dark-toned blue-purple, cool against reds, but warming by comparison with yellow-greens

Prussian Blue: Heavily dark-toned, rich and very intense with greenish undertone, usually cool

Viridian: Lower mid-toned, rich bluish-green, cool

Hooker's Green: Mid-toned, bluish undertone, cool

Yellow Ochre: Mid-toned, deep yellow tending to brown, warm

Raw Sienna: Lower mid-toned, yellow-tinged brown, usually warm

Burnt Sienna: Mid- to dark-toned, rich red-brown, warm

You will also find that not all colours are equally available in different paint ranges, and that certain colours are not available in particular media: equivalents can be slightly different in character and performance.

EVALUATING COLOURS

To become more confident in using colours, you need to gain a personal feeling for their specific characteristics that you can relate to the general principles so far discussed, and to the practical effects of mixing colours and making them work together effectively in your paintings.

You may have noticed that the colour wheel arrangement did not accommodate the full range of commercially produced paint colours; for example, the wide variety of earth colours. But you can assess those colours in terms of a relationship to a particular hue (red-brown or green-brown), a tonal value (mid-brown or dark brown) and perhaps also a temperature (a red-brown seems warm compared to a greenish-brown, which is cool). In this way you can fit them into the system of related and opposite colours proposed by the arrangement of the wheel.

The chart on this page shows colour swatches of paints taken from Daler-Rowney watercolour ranges, captioned with various properties that I see in each colour. This is a personal assessment, and you may not agree with every category, but it demonstrates a way of making the colour name on the tube mean more to you for the practical purposes of selecting your palette and combining the colours.

Cadmium Yellow: Light-toned, very intense orange-yellow; warm

Chrome Orange: Upper mid-toned, yellow-orange, warm

Cadmium Orange Upper mid-toned, very intense red-orange, warm

Crimson Alizarin: Lower mid-toned, bluish undertone, warm but slightly cooler than orange-reds

Rose Madder: Lower mid-toned, bluish undertone, slightly less intense than Crimson Alizarin but similar warm/cool variation

Indian Red: Lower mid-toned, intense but heavily brownish-red, warm

Ultramarine: Lower mid-toned, reddish undertone, cool against reds or red-purples, but warmer than other blues

Cobalt Blue: Mid-toned, intense, clear blue with slightly greenish undertone, cool

Coeruleum: Mid-toned, intense blue with greenish undertone, cool

Leaf Green: Upper mid-toned, intense green with yellow bias, cool

Sap Green: Lower mid-toned, yellow-tinged green, cool

Terre Verte: Dark-toned, low intensity neutralized green, cool

Raw Umber: Dark-toned, low intensity, slightly greenish, cool

Burnt Umber: Dark-toned, neutralized red tinge, variable warm/cool effect

Sepia: Heavily dark-toned, neutral grey-brown, cool

PAINT MEDIA

Paint consists primarily of pigment mixed with a binding medium that gives the paint its texture and fluidity. Oil paint has an oil binder; acrylics are based on synthetic polymer resins; watercolour and gouache contain gum binder. Other substances may be incorporated in small amounts to improve the paint's viscosity and flow. It is the ingredients of the paint that give it characteristic handling properties, which affect both the techniques you can use for applying it and the surface effects you produce.

QUALITIES OF PAINT MEDIA

Daler-Rowney produce oil and watercolour paints in two ranges. Artists' colours are manufactured to the very highest standards for professional use. Georgian colours are good-quality paints suitable for students and beginners. The two ranges differ in the colours available and the pricing of the tubes. You may prefer to try out either medium using the less expensive Georgian colours and, if you wish, move on to the Artists' colours as you become more confident and ambitious in your painting. Georgian colours have been used in the demonstration pictures for this book.

A basic difference between types of painting media is the capacity to produce an opaque

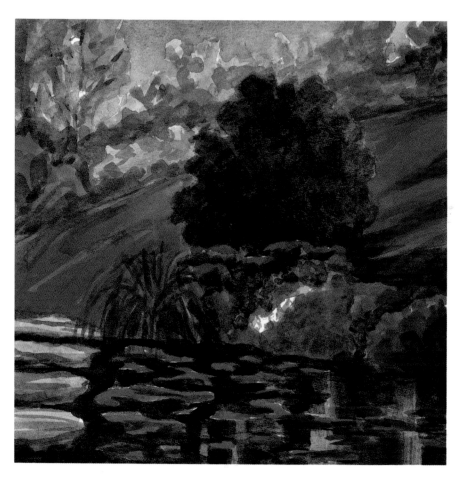

or transparent colour layer. Oils, acrylics and gouache are opaque media; that is, they rapidly cover up the working surface and light colours can be laid over dark as the painting progresses. Watercolour is transparent in that, applied to white paper, the white of the surface is seen through it and gives luminosity to the paint colour. Light-coloured pigments overlaid on darker ones cannot obliterate the underlying colour.

However, diluting any paint medium with an appropriate

▲ *The technique of building up watercolour in washes enables you to produce luminous pale or bright colours offset by densely layered dark colours. If you work too tentatively the picture will appear washed out and flat and if you work too heavily, you will lose the lights. The right balance comes with practice.*
Palette: Lemon Yellow, Cadmium Yellow, Viridian, Ultramarine, Vermilion, Mauve, Raw Umber

thinner makes the colour appear paler and more translucent. Thin layers of transparent or semi-transparent colour are known as glazes or washes.

You can make watercolour hues more opaque by adding white, but this dulls the luminosity of the colours. Pure whites are usually supplied by the white of the paper – leaving the surface bare. As a rule, white is used in watercolour painting only in the final stages, to dash in brilliant highlights where necessary. Opaque white used in this way is called 'body colour', which is also a synonym for gouache.

WATERCOLOUR

This is a very pure medium, consisting of pigments in a natural gum binder, which is diluted with water – some artists prefer using distilled water to avoid any chemical impurities that might devalue the freshness of the pigments. Dilution lightens the colours, because the paper surface is more visible through the paint. Colour washes also lighten a bit more as they dry.

The normal technique of working with watercolour is to build up the intensity of colour and tone by overlaying washes, working from light to dark. Complex variations of tone and hue are produced by gradually reducing the extent of broad colour areas and refining individual shapes and details.

▼ *Gouache has an even, matt finish; active brushwork will enliven the surface. As the paint is fully opaque, you can rework light tones over darker colours to bring out the details.*

Palette: Spectrum Yellow, Leaf Green, Ultramarine, Cadmium Red, Vandyke Brown, Purple Lake, Permanent White

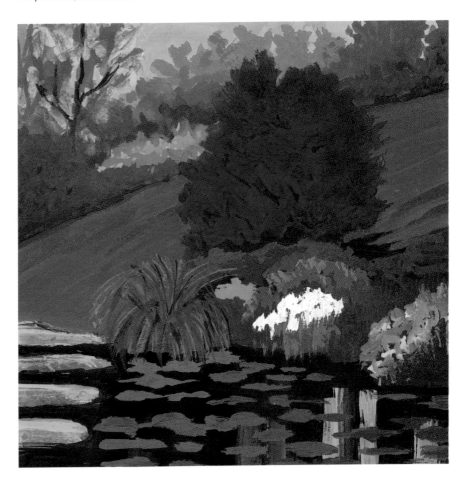

GOUACHE

This medium is like an opaque, more solid watercolour, thick-textured and quick-drying. The paint is given opacity during the manufacturing process by the addition of white pigment to all colours – this creates the typical matt, slightly chalky finish. Thinned washes of gouache are not very effective as the chalky texture of the paint deadens the colour, but applied quite boldly and heavily, the colours can appear very fresh and brilliant.

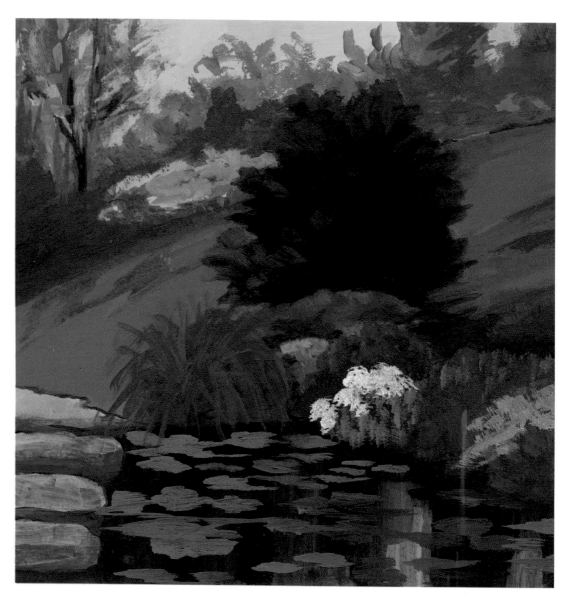

ACRYLICS

The synthetic binder in acrylic paints dries very rapidly. In most types, once the paint has dried it cannot be reworked, as it forms a cohesive 'plastic skin' that does not dissolve in water – this often has a slightly glossy appearance. You can apply glazes over thick, opaque colour, unlike using oils, and you can cover and rework previously applied colours, as each layer dries so quickly; but blending can be more difficult as the paint does not remain movable for very long. The colours are thinned with water,

and various types of mediums and gels are available to alter the thickness and surface finish of the paint.

Although acrylic is used as an opaque medium and the image is typically built up by heavy overpainting, some tube colours are relatively translucent when first applied, especially if they are thinned with water. Either apply the paint as thickly as possible at first, or build up two or three layers to make the colour heavier. Mixing in a touch of white helps to increase opacity.

▲ *Many acrylic colours are naturally bright and vibrant, but as you add layers of solid, opaque paint you can obtain dark tones and neutral colours that are rich and heavy. Handling properties of acrylics are similar to those of gouache, but the surface finish of the painting is glossier and more intense.*

Palette: Lemon Yellow, Cadmium Yellow Bright Green, Ultramarine, Cadmium Red, Raw Umber, Red Violet, Titanium White

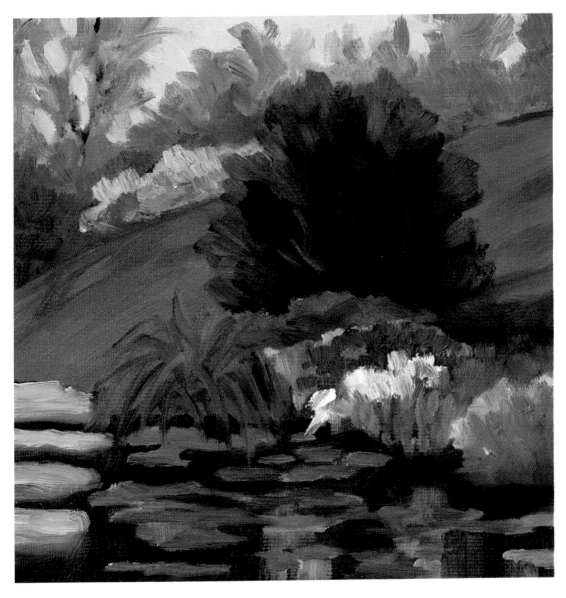

OILS

The oil binder takes a long time to dry, so the surface of an oil painting remains movable over a period of time. You can apply colours thinly or thickly, diluted with turpentine and/or oil, and blend them easily together. However, where the paint is relatively thick, it is difficult to rework the surface without picking up the colour underneath. You may need to work on a painting over several days, allowing time for partial drying between layers.

Thick paint dries more slowly than thinned glazes, so if you are layering colours the recommended technique is working 'fat over lean' – thick over thin – gradually building up the richer texture. Otherwise, the thin top layer dries more quickly than the thick layer underneath, and the surface may crack if there is movement in the underlayer as it dries. This kind of gradual layering process is a traditional oil technique.

▲ *Oil paint has a juicy texture and the colours dry true, so the finished painting retains the vitality of the colours you put down. You can build up a full range of hues and tones, but oils can be difficult to handle at first because they are slow-drying and your brushwork continually disturbs the surface. You will gradually develop a touch that enables you to work fine details into still-wet underlayers.*
Palette: Cadmium Yellow, Viridian, French Ultramarine, Cadmium Red, Burnt Sienna, Permanent Mauve, Titanium White

SURFACE MIXING

If you look at paintings hung in a gallery, you will be aware that the impression you get of a painted surface is very different according to whether you see the painting from across the room, or from close to. An area that seems to consist of solid, flat colour from a distance may be revealed as a busy network of individual brushmarks and a variety of colour fragments when you move closer.

There are various techniques for achieving complex colour effects on the surface of the picture rather than by pre-mixing on the palette. Some are very disciplined, others very loose and free.

OVERLAID COLOURS

Provided your medium allows you to create a transparent wash or glaze of colour, you can mix colours on the surface very simply by laying one over another. Traditional watercolour technique is a classic example of this principle – you build up the strength of tones and colours in successive layers, working from the lightest tones towards the darkest.

Glazing is easiest with acrylic paints, which dry very quickly so you can keep working continuously. Although acrylics can be used heavily and opaquely, when thinned with water, or mixed with an acrylic medium

▲ *To obtain a clean effect of one colour overlaid on another, wait until the first wash is 'touch-dry' before applying the second colour. Don't make the colours too wet, or they will dissolve the underlayers and muddy the mixes.*

◀ *Acrylics dry very quickly and, once dry, are insoluble, so you can rapidly build up glazed layers. Because the paint texture is thicker than that of watercolour, you can obtain a distinct colour variation by glazing light colours over dark as well as vice versa.*

and water, the colours become highly translucent.

Scumbling is a way of layering colours that enables you to work light tones over dark. The overlaid 'glaze' is semi-opaque and you brush it on very lightly and freely, so the underlying colour may show through not only the translucent colour but also in fragments that break through between brushstrokes.

OPTICAL MIXING

You can create the impression of a mixed colour using a mass of individual marks – dots, dashes or streaks – mingling component hues and tones. The effect is known as optical mixing, as it relies on a visual sensation of colours interacting on the surface, not on a physical blend of materials.

Generally, optical mixtures work in the same ways as mixtures on the palette, and correspond to the basic principles of colour relationships described in relation to hues and tones (see pages 6–11). Mixtures of primary pairs form secondary colours; primaries and related secondaries provide intermediary hues; light and dark tones form the impression of mid-tones; complementary and unlike colours create neutralized colours.

▲ *The semi-opaque scumbled glaze is lighter in tone than the ground colour, so that it forms a subtly coloured veil. Dilute the paint so it flows easily and brush lightly with a scrubbing or circular motion.*

▲ *Stippling builds up tiny dabs of colour so they that gradually merge into broad colour areas, you can vary tone and hue to create colour mixes or tonal modelling.*

SURFACE MIXING TECHNIQUES

If you want to obtain a particular mix, you need to use a controlled technique, so that the proportions of one colour to another interact effectively. The smaller the marks, the more readily the colours mix in the viewer's eye. The classic technique for optical mixing is a kind of coarse stippling – dots and dabs of colour. The principle was used by the French artist Georges Seurat (1859–91) in the style known as Divisionism, or Pointillism.

Spattering is another dot technique, but the marks are made by flicking the colour from the brush, not by direct contact. The spattered texture is random but very fine, unlike the heavier effect of stippling. You can control the balance of colour quite accurately, but you may need to mask off the shape you are spattering (newspaper is an adequate masking material) to avoid flecks of colour splashing all over the painting.

Dry brushing creates a rough-textured surface of opaque, fragmented colour.

The technique works for all media. You load the brush with paint, then blot it, and spread the hairs of the brush between finger and thumb to 'feather' the surface with fine linear strokes. You can use it to lay one colour over another or to build up a more integrated, massed texture in three or more colours.

▲ *For the dry brush technique to work well in watercolour, the paint should not be thinned too much with water. Blot excess colour from the brush and spread the bristles, then work with quick, feathering strokes.*

▲ *Spattering is very fine-textured so you need to brush in an underlayer of flat colour. Load your brush with wet paint, then draw your thumb or* finger through the bristles so that the colour flies off in a spray. You can use a stiff hog-hair brush or an old toothbrush.

▲ *The dry brush technique used for this sample is the same as for the watercolour swatch, but using gouache in four neutral shades.*

BROKEN COLOUR

The effect known as broken colour comes from an active painting technique that enables the artist to make the most of colour values. Instead of looking at the colours of whole shapes, and working out how they are modified by tone and reflected colour, you respond directly to the individual colour fragments that you see.

Working with broken colour is a less formal process than arranging optical mixtures. You can use similar principles to make mixed and gradated colours, but you may also be using colours pre-mixed on the palette. It frees you from making large decisions about the colours of whole shapes – both positive and negative areas of the image, both lit surfaces and shadows, can contain a great variety of colours.

Broken colour typically reflects the movement of the brush and has a busy surface texture.

▲ Here the picture is built up in a series of individual strokes and small patches of colour, which gradually come together to form whole shapes. Broken colour is a quick, responsive way of working that makes it easy to adjust the interaction of colours and tones.

COLOUR AND LIGHT

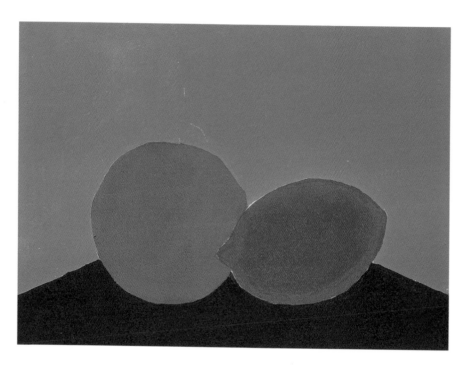

One of the problems of identifying colours in order to be able to mix them is that much of the colour you see in the world around you depends on the effects of light, rather than on the actual colours of materials and objects. Although it is light that imparts colour to our surroundings, the 'behaviour' of colour in light is quite different from that of pigment colours. It is not necessary to investigate the science of light to find out what its effects mean to you as a painter – the important thing is to believe the evidence of your own eyes.

Just as the outline shape of an object, or the layout of a scene, can appear to vary depending on your viewpoint, so the colours of surfaces and objects that you see can change according to the direction, intensity and colour of the light falling on them. Light also causes interactions between individual colours in the subject, and modifies colours in interesting ways.

COLOUR VARIATIONS

If painting were a straightforward matter of matching the 'real' colours of individual objects or materials, colour mixing would be less of a problem. But there are various influences producing infinitely subtle gradations of hue and tone even on a relatively simple shape – the regular curve of an ordinary cup or plate, for example.

It is often necessary to simplify the visual information, to avoid

▲ *In this simple still life, each object or surface has a uniform local colour that fills the whole shape. When you look at the local colours isolated here, notice that the hues are fairly evenly matched in brightness and tone.*

producing a painting that is so complex on the surface as to disguise the important characteristics of its subject. This means you have to select the most descriptive colour elements – not necessarily the most basic, but those that reveal essential information and also enliven the painting as an image in its own right.

Learn to look for and separately identify three major components of descriptive colour:

● Local colour – the 'true' colour of an object or material, which you would naturally mention if describing it in words: the local colour of a lemon is yellow; of an apple, green.

● Tonal modelling – the pattern of light and shadow that emphasizes individual forms and their location within the surrounding space. This can modify or even obliterate the local colour.

● Reflected colour – any object can reflect some colour from its surroundings or from other nearby objects. This can be no more than a subtle 'bloom' appreciably different in hue and tone from the object's local colour; but it can create an intensely colourful effect, sometimes quite unexpectedly placed and counteracting the impression of neutral colour in the shadow areas.

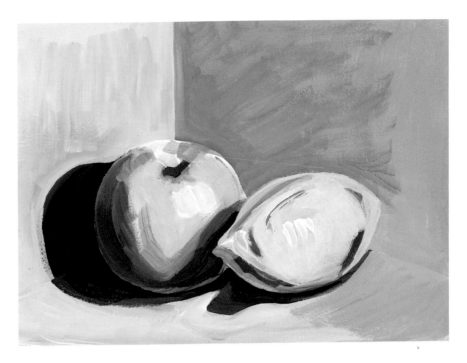

▲ A pattern of light and shadow is formed independently of the local colours, according to the amount of light falling on any part of a surface or shape. To show tonal modelling as a separate element, I have painted a second version here purely in monochrome.

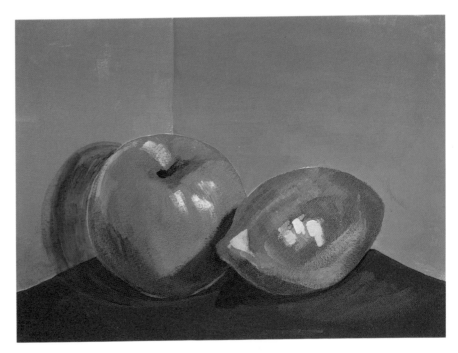

▲ Reflected colour can give even a simple painting some lively colour variation, like the brilliant red reflected from the ground plane on to the underside of the lemon, and the blue tints on the apple reflecting from the background. Notice that these are integrated with the tonal pattern, and some of the strongest reflected colours are cast on to the darkest areas of shading.

LOOKING AT COLOURS

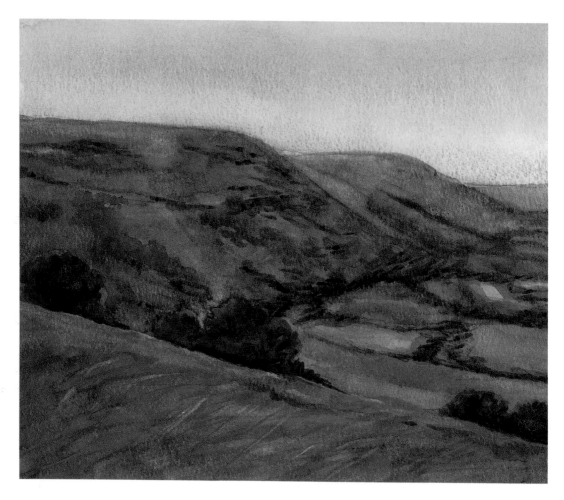

There are different ways of starting off a painting, but one that experienced artists frequently recommend is blocking in an overall impression of the main shapes and their colours, before grappling with any detail. With this approach, you are likely to be considering first the local colours of objects and surfaces in the image. These help you to identify what the different parts of your picture represent – individually coloured objects in a still life, for example, or the pattern of colour areas in a landscape that create basic divisions of land and sky.

In doing so, you broadly establish a colour key for your painting which will influence the decisions you make about developing the variations of local colour, tonal modelling and reflected colour as you build up detail in the painting. The colours that you first put down become a sort of 'reference chart' against which you measure the hue and tone of colours that you subsequently add.

▲ *In these two paintings of the same subject in different media (above and opposite), I have adjusted the key of both colours and tones. In the watercolour version here, the greens are mainly tinged with yellow, orange and red, giving a warm colour key described mainly in mid-tones, with occasional contrasts of light and dark.*

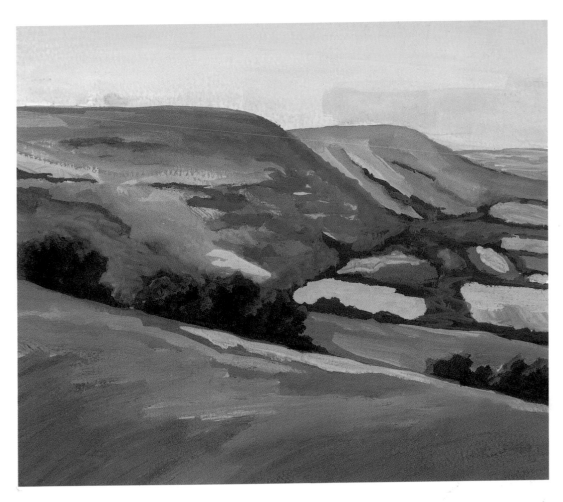

MATCHING YOUR SUBJECT

An accurate eye for colour, and the ability to select colours on your palette that will corrrespond to what you see, is a combination of skills that improves with experience. Unfortunately there are no magic formulas, as every subject contains a new set of colour variations and subtle nuances. You must always start fresh with the information in front of you, and not make guesses or assumptions.

To achieve a good 'match' for a specific colour, analyse its individual properties – hue, tone, intensity, 'temperature' (see pages 6–15) – to find the right kind of paint colour from which to start mixing. Having chosen a colour, you need to work out which way you want to take it – for example, blue towards purple, green towards yellow – so that you know what other paint colour it should be mixed with.

FINDING A KEY

Exact colour matching is not essential to building up your painting – the picture depends on effective relationships of colour and tone which are made to work independently of the subject. What you need to find is the right balance of different elements – the biases of individual hues, the range of light, middle and dark tones, and perhaps also the variations of warm and cool colours.

The tonal key is very important. This is a basic ingredient of composition that helps you to render space and form convincingly.

▲ *In the gouache version here, I have brought up the tonal key, making most of the colours lighter to heighten the sunlit impression. I have also 'blued' the darker greens, to make these cooler by contrast against the warm yellow tints. Both paintings have a satisfactory balance in their own terms.*

CHOOSING YOUR PALETTE

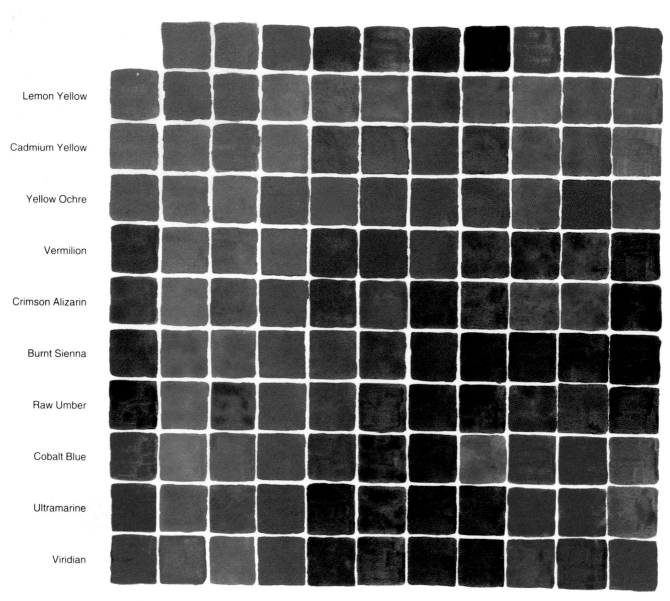

Lemon Yellow

Cadmium Yellow

Yellow Ochre

Vermilion

Crimson Alizarin

Burnt Sienna

Raw Umber

Cobalt Blue

Ultramarine

Viridian

A simple way of establishing your basic palette is to buy a boxed set of colours or starter pack. The number and range of the colours selected varies from around six to twelve individual tubes. All represent versatile and popular colours that have proven value as mixers.

The colour charts on these pages are developed from Daler-Rowney introductory packs of watercolours, oils, acrylics and gouache. The main chart in each section shows the basic range of two-colour mixes, incorporating variations in the mixed colours depending on which component

▲ *The pure watercolours are shown along the top row and down the left-hand column of squares, so you find the mixes by aligning from selected squares at top and side. The dominant ingredient of the mix is shown by the top square in each vertical column. The blocks running diagonally show each colour mixed with itself.*

colour is in larger proportion. From these you can see at a glance whether particular hues that you might want to mix – true purples, for instance, or bright greens – are easily created with the given colours.

Three-colour mixes tend to produce darkened and neutralized colours (see pages 8–9). I have charted the widest variety of colour mixes from the watercolour palette; for the remaining media, you can estimate that similar mixtures, based on named colours, will have similar effects.

These charts will also be useful if you prefer to build up your stock of paints by selecting individual tubes, rather than a boxed set, or for adding colours to fill out the range of a limited palette.

WATERCOLOUR

The chart on the left is based on the Daler-Rowney Introduction to Watercolour, containing twelve tubes of Georgian watercolours including Ivory Black and Chinese White. In traditional watercolour technique, you use the white only for final highlighting, not as a mixer colour.

TWO-COLOUR MIXES
The chart shows each of the ten colours (not including black and white) mixed in two proportions with each of the others. For example, where a yellow and blue are mixed, in one mixture the yellow predominates, forming a yellow-green, and in the other blue predominates, forming a blue-green.

There are ninety colours on this chart in addition to the basic ten, using only two mixtures of different proportions for each pair. Since you could probably

obtain three or four distinctly different mixes from all of the colour pairs, you could easily develop a palette with up to two hundred shades. This is more than adequate for most types of watercolour work, in the studio or outdoors.

COLOUR RANGE
This watercolour set contains two different values of each of the primary colours – red, yellow and blue – so it is possible to create a good range of secondaries – green, orange and violet. In particular, the oranges are clear and fresh, and the red-violets and blue-violets mixed from Crimson Alizarin with Ultramarine or Cobalt Blue are quite strong and vibrant.

The greens mixed from the two yellows and blues form some attractive, subtle yellow-greens and blue-greens. They lack a very intense, vivid green as a mixed colour, but this is compensated by the addition of Viridian to the palette, which creates the stronger emerald, leaf green and sea-green hues when mixed with yellow or blue.

MIXING WITH BLACK
As there are plenty of attractive browns, dark blues and muted greens on the two-colour chart, mixed from pure hues, the tube of black is not essential as a mixer, since it will produce similar colours if mixed with the reds, blues or green included in the set. But it is very useful as a mixer with yellows, producing a subtle range of olivey greens slightly harder than those of the blue/yellow mixes.

▲ *Adding black darkens and neutralizes the pure hues, eventually producing a distinctly different colour shade.*

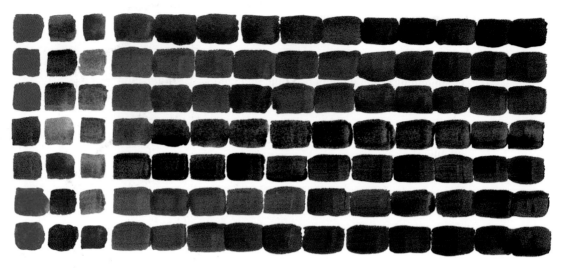

▲ *Each band of colours begins with a three-colour mix in which the first of the pure hues shown on the left is dominant. The successive colours across the row represent alternately increasing proportions of the other two component hues.*

THREE-COLOUR MIXES

In keeping with the theoretical principles of mixing related and complementary colours, three-colour mixes tend to produce neutralized colours because they usually include a complementary element. Common examples are three component colours that correspond to all three primaries – red, yellow and blue, or two related colours and one complementary – red, yellow and green.

As the chart above shows, the mixed colours are mainly in the muted brown and green range, with some brownish-purples and blackish-blues, depending on proportions in the mix.

GOUACHE

The Daler-Rowney Designer's Gouache Introduction Set also contains twelve colours, including Lamp Black and Permanent White. As with the watercolours, you can create a generous extended palette using only two-colour mixes, but there are some important differences in the basic colour selection.

TWO-COLOUR MIXES

In the chart opposite you will see that the orange-red is Cadmium Red rather than the Vermilion included in the watercolour palette, but it gives similar mixed effects. Instead of the bluish red, Crimson Alizarin, however, which created the violet and purple shades in watercolour, you have Mars Red, which is a brownish red. Nothing is lost, as the gouache set contains an actual purple – Brilliant Violet – which mixed with the reds and blues provides a broad purple/violet range.

There is only one bright yellow – Spectrum Yellow – to contribute to the range of oranges and greens. Supplement this with the lighter, fresher Lemon Yellow, to create a slightly different effect in the secondary colours. But the palette as it is includes a reasonable variation between red-orange and yellow-orange in the mixed hues, and between yellow-green and blue-green.

The two blues, Ultramarine and Coeruleum, provide a good contrast of hue and tone, and allow you to vary the green and violet mixtures considerably. The deep-toned, bluish green is Viridian, but you can make citrus

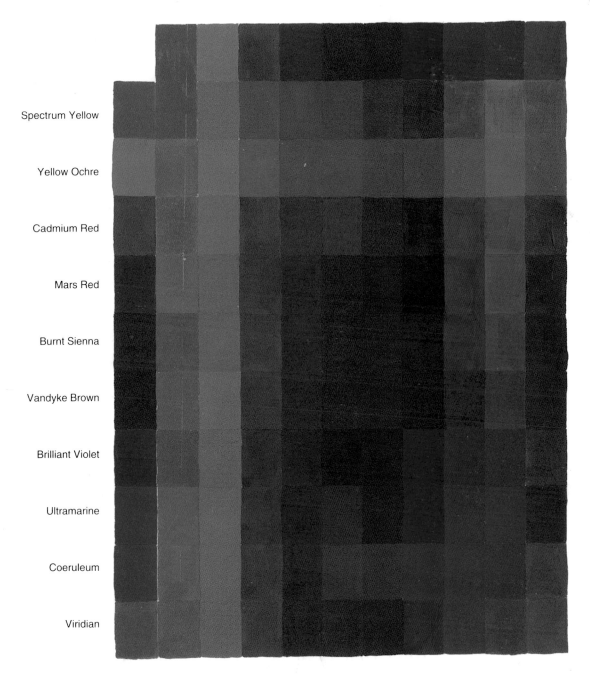

Spectrum Yellow

Yellow Ochre

Cadmium Red

Mars Red

Burnt Sienna

Vandyke Brown

Brilliant Violet

Ultramarine

Coeruleum

Viridian

▲ *The gouache chart works the same way as the watercolour version, with the pure tube colours along the top and down the left hand side. The top row shows the dominant colour in the mixture, when aligned with any given hue from the left-hand column.*

and olive greens by mixing yellow and black.

Yellow Ochre, Burnt Sienna and Vandyke Brown provide a wide range of rich browns and are also a useful means of 'knocking down' the brighter colours, creating a powerful selection of neutralized blues and greens, as well as browns. The complementary pairs of red/green, yellow/purple and blue/orange-red also produce some interesting neutrals.

ACRYLICS

The Daler-Rowney Introduction to Cryla Artists' Acrylic Colour contains only six colours plus Mars Black and Titanium White. The six colours are shown on the chart overleaf as two-colour mixes in three different proportions – a mixture designed to produce a 'midway' colour, plus another mixed colour on either side showing one dominant ingredient.

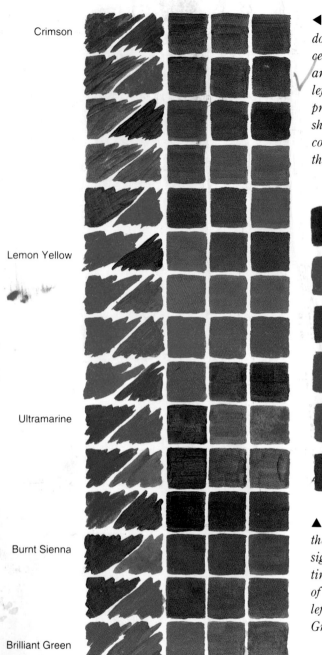

Crimson

Lemon Yellow

Ultramarine

Burnt Sienna

Brilliant Green

◀ *The pairs for each mix are shown down the left-hand column. The centre block in each set of three shows an average mixture; the colours on the left or right of this contain a greater proportion of the left or right colour as shown in the original pairs. The tube colours are shown in the annotation; the sixth colour is Yellow Ochre.*

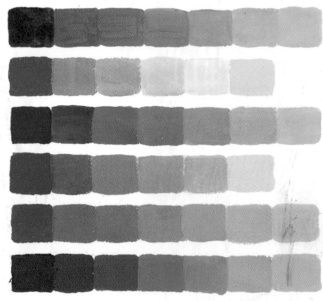

▲ *The lighter the original tube colour, the more difficult it is to obtain a significantly different range of pale tints by adding white. These are tints of the main colours in the chart on the left. With the Lemon Yellow and Leaf Green, the colour rapidly fades out.*

TWO-COLOUR MIXES

Six colours naturally provide a narrower range of mixed hues than eight or twelve; nevertheless, the forty-five colours include a surprising range of greens and a variety of rich, warm shades passing from yellow through orange and red to brown. However, if you intend to do a lot of landscape work, you might wish to increase your range of greens by adding, say, Monestial Green or Hooker's Green. What the palette obviously lacks is sufficient variation representing the blue and purple segments of the colour wheel. It would be advisable to add a different type of blue from the Ultramarine that is given – either Cobalt Blue or Coeruleum – and, for your purple, Permanent Violet. Alternatively, you might choose Red Violet and create your blue-purples by adding Ultramarine.

MIXING WITH WHITE

With all the opaque media, you will frequently be adding white to the colours to create your mid- to light tones. Usually, you can estimate quite accurately how this will affect the original colour. The more white you add, the more different in character the colour becomes – for example, look at the palest tones of Yellow Ochre and Burnt Sienna on the tint chart shown above.

Cadmium Red

Cadmium Yellow

French Ultramarine

Viridian

◀ *This chart works in the same way as the one for acrylics opposite. The pairs contributing to the mixed colours are shown down the left-hand side, and there are mixtures in three different proportions. The tube colours are shown in the annotation; the fifth colour is Burnt Sienna.*

OILS

The Daler-Rowney Georgian Oil Painting Set consists of only five colours plus Titanium White and Ivory Black. It also includes the turpentine and oil mediums you need for diluting and mixing the colours, so it is an economical way to start. However, the small number of individual colours obviously means your overall palette is relatively restricted.

TWO-COLOUR MIXES
From the chart, you can immediately see that the range of mixed colours is somewhat subdued, although you have a few very brilliant, clear oranges and greens from the mixtures of Cadmium Red or Viridian with Cadmium Yellow. The French Ultramarine and Cadmium Yellow mixtures produce slightly duller, but natural-looking greens.

As with the acrylic palette, the obvious missing element is a clear violet or purple, since Cadmium Red and French Ultramarine make a neutralized, brownish mixture.

EXTENDING YOUR PALETTE
One of the simplest ways to give yourself more options for colour mixing is to add a different value from each of the three primary colours. You have Cadmium Red, so your supplementary should be a bluish-red – Crimson Alizarin is the most popular choice. The Cadmium Yellow is a warm, strong yellow, so you might choose the lighter, slightly greenish Lemon Yellow. The additional blue could be Cobalt or Coeruleum – if you intend painting outdoor views, Coeruleum is a good mixer for sky colours (see pages 54–5).

These additional colours appear in the watercolour and gouache ranges (see pages 28 and 31), so you can see how they provide different types of mixes that form a broader overall colour range. However, in oil paint, a mixture of Crimson Alizarin and French Ultramarine does not produce a true purple – the mixture is brownish-black. It is worth including a tube purple in your palette, such as Permanent Magenta (red-purple) or Permanent Mauve (blue-purple).

REDS AND ORANGES

As a primary colour, red is one of the essential ingredients of your palette, both as a colour in its own right and for mixing and modifying other colours. It makes a very strong effect as a dominant colour in a painting, but even used discreetly as an accenting colour, it helps to light up an image and give it impact.

Orange is a less powerful and less frequently seen colour, and the variety of orange hues is restricted. The range of pure orange is quite narrow – it easily shades into yellow, red or brown.

USING REDS

Reds are strong mixers, so be especially careful when using them to colour lighter-toned hues. To mix orange, for example, add the red to the yellow in small amounts, building up to the strength you require, otherwise you may waste paint trying to add enough yellow to red to vary the hue effectively. Reds also make very brilliant, strong tints with white.

Adding black has a dull effect on red, producing neutralized, dense browns. Reds can be darkened more colourfully by mixing in the complementary colour, green, or the nearly complementary colour, blue Alternatively, blue-reds can be shaded with purple.

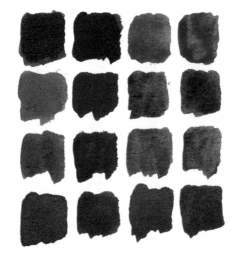

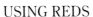

◀ *This chart shows how the reds naturally divide into orangey and bluish hues, which tend to produce brownish or violet shades respectively when mixed with unlike colours. The pure reds (top row) are Vermilion, Cadmium Red, Crimson Alizarin and Rose Madder; each is mixed (reading downwards) with Ultramarine, Viridian and Cadmium Yellow.*

▲ *The local colour of the tomato is Vermilion with a touch of Lemon Yellow. The mid-tone is made by adding more Vermilion, the darker shading by adding a little Ultramarine and more yellow. The radishes are painted with the blue-red, Crimson Alizarin, shaded with Ultramarine and brightened with Lemon Yellow.*

MIXING ORANGES

There are very few orange tube colours, and it is not essential to include one in your colour stock. You can usually mix quite satisfactory oranges from yellows and reds. The typical oranges are Chrome Orange, usually yellowish, and Cadmium Orange, which is stronger and more red. However, oranges are made with mixed pigments and hues can vary considerably between one type of paint and another.

You can brighten oranges by adding yellow, red or a touch of white, shade them by mixing from the opposite side of the colour wheel, adding blue or green. But be sparing when using another colour to modify a bright orange mix, as it can quickly devalue and lose the characteristic quality of the hue.

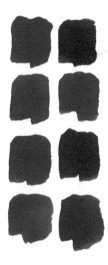

▲ These are orange tube colours (top), Chrome Orange and Cadmium Orange. The vertical rows show the effect of modifying with Ultramarine, Crimson Alizarin and Viridian, all added in very small amounts.

▲ These two studies use the same restricted palette – Spectrum (gouache) or Cadmium (watercolour) Yellow, Cadmium Red, Burnt Sienna and Coeruleum. The gouache colours are more delicate and have the slightly chalky finish typical of the medium; the transparent watercolour hues are clearer and more intense. But both paintings provide a balance of hue and tone related to the subject.

YELLOWS AND GREENS

Almost all of the wide range of greens now available to the artist are artificial colours. Despite the variety of greens in nature, there are few reliable natural pigment sources. The brightening of the landscape palette brought about by the Impressionists in the second half of the nineteenth century was not just due to new ideas about painting – it became possible because new artists' colours were being manufactured, a valuable spin-off from major industrial developments.

At the same time, the introduction of Chrome, Cadmium and Cobalt colours provided some more permanent and intense yellows,

as well as blues, greens and violets. Cadmium Yellow, for example, has become a mainstay of the modern palette. If you compare it to the slightly subdued Aureolin or earthy Yellow Ochre, it is easy to see the artificial, brilliant quality of the pigment and appreciate the freshness it contributes to colour mixes.

COLOUR RANGES

This comparison of natural and artificial colours extends into the real world. We associate greens and yellows very much with landscape colours, but in that

▲ *The key to these strong natural greens and yellows is the use of Cadmium Red in the palette. The rich, dense hue of the green pepper is mixed from Viridian, Cadmium Yellow and Cadmium Red, the vivid yellow pepper from Cadmium Yellow and Red. A mix of red and green gives the brownish tones used for shadows and details. The highlights are brightened with Titanium White.*

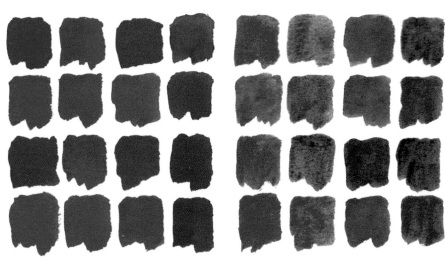

▲ These examples of tube yellows are very different in character: (top row) Lemon Yellow, Aureolin, Cadmium Yellow and Yellow Ochre. But notice how much they are all influenced by even tiny amounts of mixer colours: (reading downwards) Cobalt Blue, Vermilion, Viridian.

▲ The tube greens are shown along the top row, Leaf Green, Hooker's Green, Sap Green and Viridian. From these four colours I have mixed twelve other shades that are all still strongly green, using Ultramarine, Vermilion and Cadmium Yellow.

context they are often relatively muted and restrained. Many landscape greens, for example, are slightly reddish – which on the basis of complementary values in mixing means that they are also slightly neutralized. Very few of the tube greens in paint ranges will correspond immediately to natural greens – you need to mix and modify them with the full range of your other colours (see pages 52–3).

Artificial greens, such as those of plastics and dyed fabrics, are more closely allied to unmixed paint colours. Similarly, in manufactured objects, yellows range from pale lemon to vibrant sunny shades. By comparison the reddish and brownish earth yellows, such as Yellow Ochre and Raw Sienna, are more obviously related to natural materials and appear more frequently in that context.

MIXING YELLOWS AND GREENS

You have to be careful when darkening yellows, because the naturally light-toned hues quickly turn green or brown in mixes. Always add your mixer colour to the yellow, rather than vice versa, in very gradual stages. Greens are more dominant and versatile – you can often add considerable amounts of other colours and still find the mixed hue is recognizably green.

▲ These plastic bottles are typical of the bright, 'sweet' colours of artificial materials. The light-toned green is composed of Leaf Green, Viridian and Titanium White, the mid-toned colour is Leaf Green and Viridian, the dark bottle Viridian and Hooker's Green, shadowed with Ultramarine. The yellow bottle is Lemon Yellow tinted with white.

BLUES AND PURPLES

These two hues provide some of the naturally deeper tones in your colour palette. Blue, as a primary colour, is an essential ingredient of any basic palette, purple is an optional addition to your range. However, as it can be very difficult to mix satisfactory purples from reds and blues, I would recommend that you do choose one tube colour, either a red-purple or blue-purple, as part of your basic stock that can be mixed and modified with other hues.

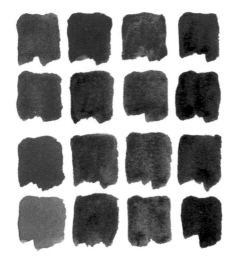

◀ *Blues are strong colours that tend to dominate mixes. Each of the blues shown here, (top row) Coeruleum, Ultramarine, Cobalt and Prussian Blue remain characterful when lightly mixed with (reading downwards) Viridian, Crimson Alizarin and Cadmium Yellow. Notice how the red begins to neutralize the greenish Coeruleum, whereas it merely warms up the deeper blues.*

SHADES OF BLUE

If you are to have only one blue in your colour set, Ultramarine is the one most frequently recommended. It is a rich, mid-toned blue with a slight reddish undertone, but mixes well with red and yellow to give a range from brown through purple, depending on the character of the red, and both subtle and vibrant greens, depending on the yellow.

The other most popular blue is Cobalt, which has a slight greenish undertone that influences mixed colours toward cool shades. Coeruleum is brighter and again greenish, a good mixer for turquoisey shades. Prussian Blue (or Monestial Blue which is a near-equivalent) is a very strong, lush, deep-toned colour that needs to be handled discreetly.

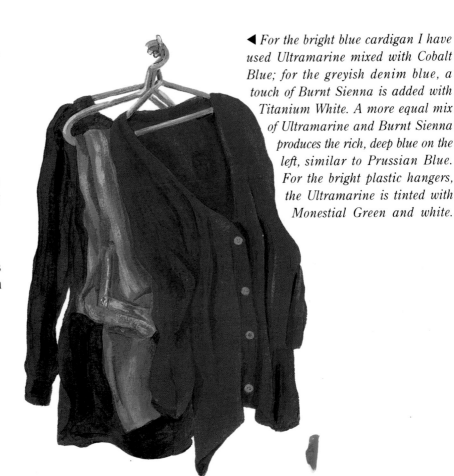

◀ *For the bright blue cardigan I have used Ultramarine mixed with Cobalt Blue; for the greyish denim blue, a touch of Burnt Sienna is added with Titanium White. A more equal mix of Ultramarine and Burnt Sienna produces the rich, deep blue on the left, similar to Prussian Blue. For the bright plastic hangers, the Ultramarine is tinted with Monestial Green and white.*

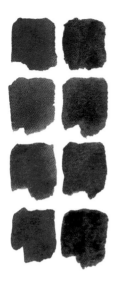

▲ *To point out the variation between red-purple and blue-purple, I have used only Permanent Magenta and Permanent Violet as the basic hues in this chart (top row). These are mixed with (reading downwards) Ultramarine, Crimson Alizarin and Cadmium Yellow. It is the complementary effect of strong yellow mixed with blue-purple that most notably changes the bias of the hue.*

THE PURPLE RANGE

In any given paint range, you will not find many tube colours in this family of hues, although they are best served in artists' oil colour ranges. I am using the term purple to cover colours usually named as magenta, mauve, violet and purple, which pass from strong red-purples through to deep blue-purples.

The purple that you choose to add to your basic palette may depend on the colours you already have. If your basic red for mixing is Crimson Alizarin, choose a blue-purple tube colour such as Permanent Mauve, that can be taken towards red by the addition of crimson. If your palette contains Cadmium Red or Vermilion, say, and Ultramarine, choose a red-purple such as Red Violet or Permanent Magenta, which can be 'blued' with Ultramarine.

Deep purples in oil, acrylic or gouache sometimes look blackish when you brush them out at full strength. If your purple is too dark, try adding a tiny touch of white – just enough to bring up the hue a little more brightly.

▼ *The basic colour in this watercolour study is Mauve mixed with Crimson Alizarin. A brighter red-purple, tinted with Cadmium Red, was also used. You can see pale washes of both these colours in the sliced cabbage sections on the right, which show the first colouring stage with areas of the white paper left bare. In the main form, I have gradually built up the deeper red-purples with successive washes and fine brush drawing, and shadowed them with Ultramarine. The shiny cabbage skin showed cold reflected lights, touched in with Coeruleum.*

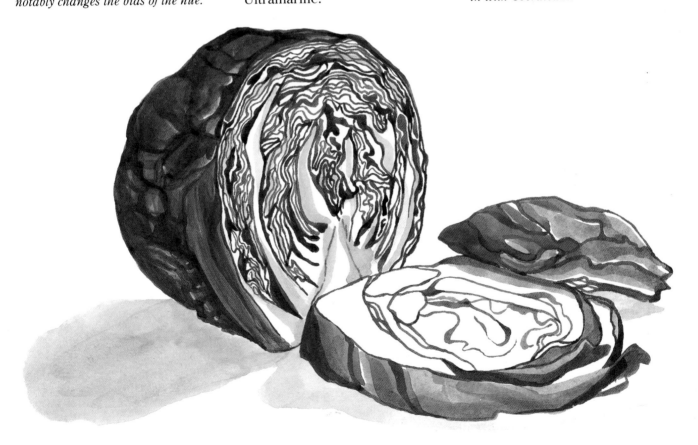

COLOURFUL WHITES

Painting a subject that is predominantly white is a particular challenge. You have to find a way of varying the colour values to shape and model the object or surface in front of you without losing the clean, unified effect of its whiteness.

All white surfaces are to some extent reflective, and may display a complex range of colour influences. You can try to separate the three basic elements of light and colour to help you analyse the surface effects – local colour, tonal modelling and reflected colour (see pages 24–5).

LOCAL COLOUR

The local colours of white materials do vary very subtly. You can see this in your everyday surroundings – matt-emulsioned white walls are different from gloss-painted woodwork. This may take the form of a distinct colour bias – some whites are obviously creamy, for example, seeming to be slightly tinged with yellow, while others are visibly bluish.

More often the difference is difficult to define strictly as colour, but you can perhaps see that one kind of white is a warm white, another is cool; one is very brilliant and intense, another flat and muted.

Unlike the strong hues, such as red and blue, you cannot rely on obvious variations in the tube colours to set the key of your picture. You do have to make decisions on mixing other colours into your white paint, to create a distinction between warm and cool or intense and muted whites. If you see a white as warm, you can add a slight touch of red, orange or yellow. If it is cool, the modifying colour may be blue or violet.

However, the colour bias can be so subtle that you need to create a neutral tint with a very slight hint of the chosen hue. These decisions are not easy,

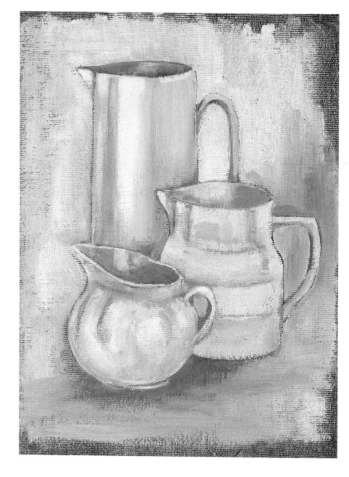

▲ *As it is difficult to work with whites on a white ground, the canvas board used for this oil study was stained with a glaze of Raw Umber. The right-hand jug had a creamy tone, created with Naples Yellow. The tall jug was a very cold white, so I used French Ultramarine to tint the light and mid-tones. The smaller jug was warm white, so it is tinted with Cadmium Red and Burnt Sienna. The tonal greys were mixed from those colours combined in different proportions with white.*

Palette: Flake White, Naples Yellow, French Ultramarine, Cadmium Red, Burnt Sienna

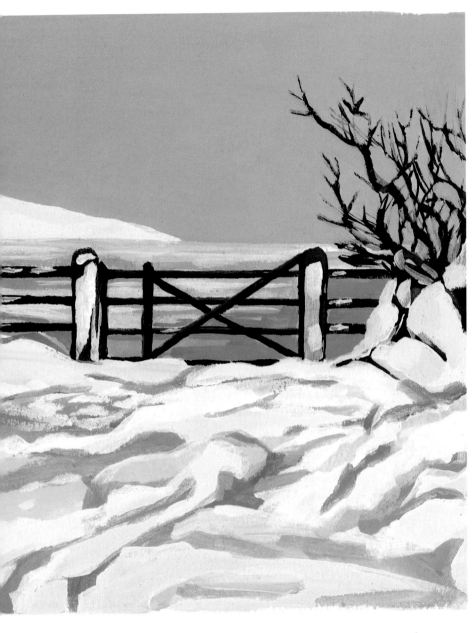

but you must come to rely on your own judgement and watch how the colours interact as you develop the painting.

EFFECTS OF LIGHT

Light creates tonal shading on white objects, and very little of the surface may appear as pure white. The 'greys' that you see in the range of tones have even more elusive colour qualities than the local colours of whites. Avoid mixing black and white to make the tones – this makes your rendering dull and harsh. Use 'coloured greys' (see page 42) based on neutralized mixes of the colour tints you have put into the clean whites.

Pay careful attention to the tonal balance of the painting – it is easy to make the variations of light and shade too soft, but they need to be delicately handled. Reflective materials can produce quite hard, strong tonal contrasts on a curved or angled surface; cast shadows can also be very dense. Reserve pure white for the very highest tones only, which may be quite small areas of the surface – the highlight reflecting off the curve or rim of a jug, for example.

Occasionally you will see strong flashes of reflected colour on shiny whites, and even matt white surfaces can have a gentle colour bloom taken from their surroundings. All such subtle variations help to make your rendering more realistic.

COLOURFUL BLACKS

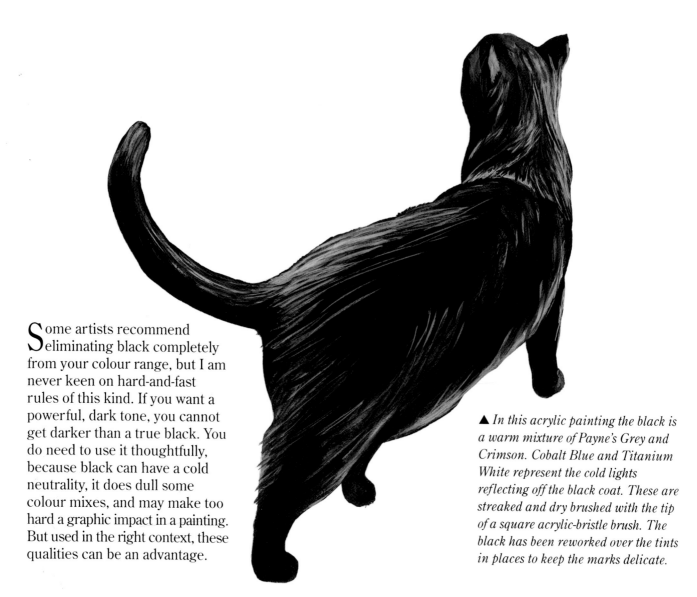

Some artists recommend eliminating black completely from your colour range, but I am never keen on hard-and-fast rules of this kind. If you want a powerful, dark tone, you cannot get darker than a true black. You do need to use it thoughtfully, because black can have a cold neutrality, it does dull some colour mixes, and may make too hard a graphic impact in a painting. But used in the right context, these qualities can be an advantage.

▲ *In this acrylic painting the black is a warm mixture of Payne's Grey and Crimson. Cobalt Blue and Titanium White represent the cold lights reflecting off the black coat. These are streaked and dry brushed with the tip of a square acrylic-bristle brush. The black has been reworked over the tints in places to keep the marks delicate.*

SHADED MIXES

What the 'no black' rule is meant to do is break a tendency to depend on black as a way of darkening colours and indicating heavy shadow. Because black is so dense and absorbent, it can appear as a flat area of the picture if treated too simply. Pure blacks

are legitimately used as local colour – when you are painting something that includes a black object or surface. If you paint with black direct from the tube, you can introduce surface variation by being careful to render highlights and reflected colours that help to explain shape and form.

To modify the appearance of black, add a colour that gives a warmer or richer bias – colours such as Ultramarine, Prussian Blue, Viridian, Crimson Alizarin, Mauve or Cobalt Violet are good mixers for black. This approach can also be used for giving a hint of colour to cast shadows and darkly shaded planes and curves.

MIXING COLOURED BLACKS

'Coloured blacks' are mixed from colours – they contain no black pigments. Choose colours that are naturally mid-to-dark-toned and that have a complementary relationship, based in opposite segments of the colour wheel. As colours combine, the mixtures appear darker still, and the complementary element makes them tend towards neutral shades.

Mixed blacks help you to shade more subtly the depth, form, and colour of dark shapes.

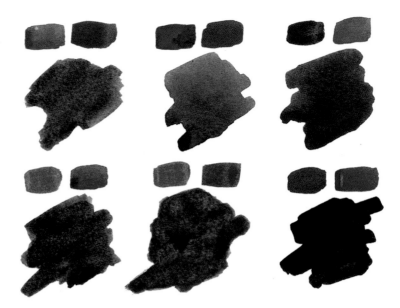

▲ *This series of 'coloured blacks' was mixed from two-colour combinations: (left to right, top) Sap Green and Mauve; Prussian Blue and Cadmium Orange; Raw Umber and Coeruleum; (bottom) Viridian and Crimson Alizarin; Viridian and Mauve; Burnt Sienna and Ultramarine.*

▼ *This two-stage picture shows how Ultramarine and Burnt Sienna have been used to underpaint cool and warm colour influences shaded into the cat's fur. Then the overall shape was washed over with Ivory Black, and highlight areas lifted out.*

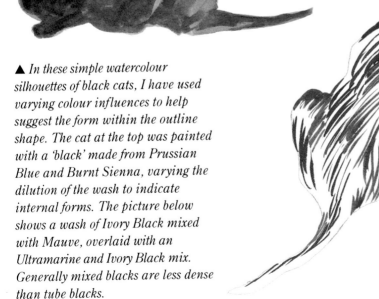

▲ *In these simple watercolour silhouettes of black cats, I have used varying colour influences to help suggest the form within the outline shape. The cat at the top was painted with a 'black' made from Prussian Blue and Burnt Sienna, varying the dilution of the wash to indicate internal forms. The picture below shows a wash of Ivory Black mixed with Mauve, overlaid with an Ultramarine and Ivory Black mix. Generally mixed blacks are less dense than tube blacks.*

EARTH COLOURS

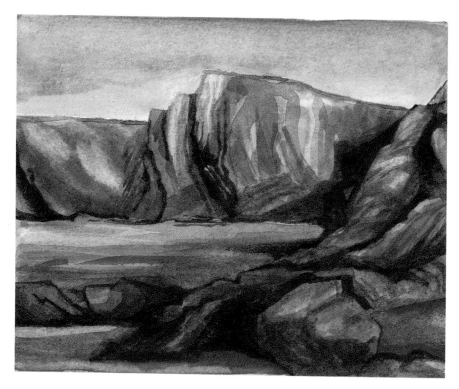

Originally derived from natural earth sources that might be found anywhere in the world, these colours consist of the brownish yellows and reds and rich, deep browns known as the ochres, siennas and umbers. Technically, the category of earth colours also includes Terre Verte, a muted, natural green earth.

SELECTING EARTH COLOURS

Among the most familiar and commonly used are Yellow Ochre and Burnt Sienna; you will often find both these colours in a boxed set of paints.

Artists value the subtlety of earth colours as mixers and modifiers for the brighter hues, especially those that are opposite in character, such as greens, blues and purples. They work well for providing deep, subtle tones in foliage colours (see page 52), unusual warm tints for skies (see page 54) and natural stone-like colours in townscapes (see page 47).

The relationship of Raw Sienna and Raw Umber to Burnt Sienna and Burnt Umber is that the same pigments are used but the 'burnt' colours are roasted. This changes not only the shade but the bias of the hue, both becoming redder and more dense. Raw Umber is useful for describing light and shade; Burnt Umber for deep shadow.

▲ *I sketched out the main shapes with Raw Umber and applied a pale wash of Yellow Ochre overall, to create a basic tonal range. The picture was then built up with overlaid washes, gradually mixing and modifying the colours. Both the luminosity of the watercolour medium and the warmth of Yellow Ochre and Raw Sienna contribute to the sunny glow.*
Palette: Yellow Ochre, Raw Sienna, Raw Umber, Coeruleum

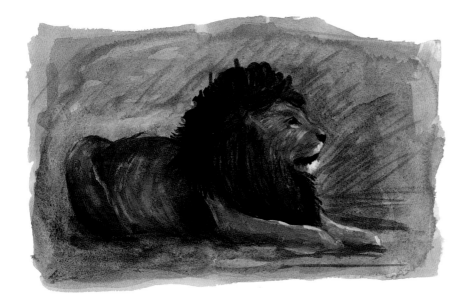

◀ *This is an acrylic study combining opaque paint and thin, diluted glazes. I used pure Mars Black in the mane and for details of the face, then glazed Yellow Ochre and Burnt Sienna together across the body, shadowing with Ultramarine. A bright touch of Cadmium Red was added to make the red-orange glints in the fur.*
Palette: Yellow Ochre, Burnt Sienna, Mars Black, Cadmium Red, Ultramarine, Titanium White

NATURAL SHADES

As a personal opinion, I find the modifying effect of earth colours sometimes over-used in painting – particularly with regard to landscape and figure subjects. These earthy tones can 'knock down' the colourfulness of the hues they are mixed with to the point where the image appears unnecessarily restrained, resulting in a sombre mood or uninviting lack of contrast.

However, the warm, subtle colours are of course particularly appropriate for natural subjects – materials such as soil, stone and sand, and the earthy colours of animals that act as camouflage in their natural environment. The examples on these pages show each of these contexts.

Blue is useful for shading earth colours and also mixes with the mid-toned colours to make greens and deeper browns, grey-brown or near-black. White is usually a necessary mixer when you are using an opaque medium, to provide the pale tones, and I would recommend adding touches of vivid artificial colour, such as Cadmium Yellow, Cadmium Orange or Cadmium

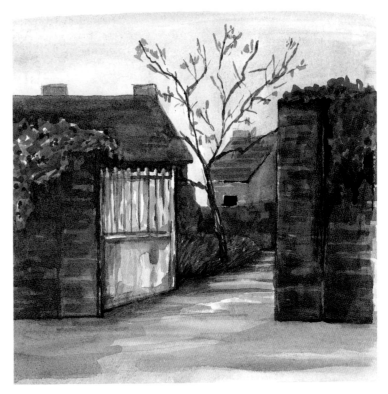

Red, to lift the more colourful highlights.

If you have a landscape subject that includes foliage greens, you may wish to add a tube green to your palette. Sap Green and Terre Verte are muted shades in keeping with the density of earth colours; Viridian or Hooker's Green provide greater intensity if vibrant greens are needed, and can be shaded down by mixing.

▲ *The low-key colour and tonal range was the attractive feature of this simple scene, with the rusted white gate forming a patch of high tone. The browns and greys were made from the earth colours mixed with Ultramarine and Crimson Alizarin; the greens were mixed from the two yellows and two blues.*
Palette: Yellow Ochre, Burnt Sienna, Cadmium Yellow, Crimson Alizarin, Cobalt Blue, Ultramarine

NEUTRALS

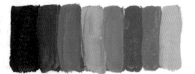

Crimson and Monastial Green

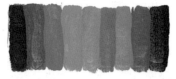

Ultramarine and Cadmium Orange

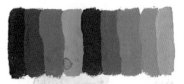

Lemon Yellow and Deep Violet

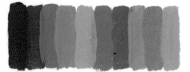

Cadmium Red and Monastial Green

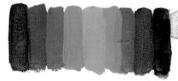

Ultramarine and Burnt Sienna

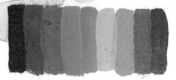

Yellow Ochre and Deep Violet

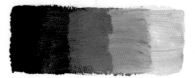

Ivory Black and Titanium White

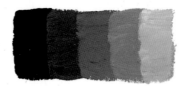

Mars Black and Titanium White

Payne's Grey and Titanium White

As a basic principle, mixing opposite or unlike colours neutralizes the intensity and character of the component hues. When painting a colourful subject, try to keep mixing to a minimum and make the most of strong colour values. But when your subject is mainly composed of subdued and neutral colours, as in a townscape or a rocky, bleak landscape, remember that paint mixtures so easily turn to sludgy greys, browns and dull greens. The important thing is to learn how to vary the neutral qualities deliberately, and make them interact attractively.

CHOOSING YOUR MIXERS

Neutrals are also known as tertiary colours, which means they include some of each of the primaries – red, yellow and blue. So neutral colours are also naturally achieved by mixing the complementary pairs of hues – red and green, blue and orange, yellow and purple.

You can obtain very rich, dark neutralized mixes from the right combinations of strong colours (see page 42). If you add white to your basic palette, you can then extend the mixtures into a wide range of neutral tones from dark to light. And you can create additional variations by adjusting the proportions of colours in a mix, so that, say, in a blue/orange combination, you can make a warm neutral by increasing the orange, a colder, deeper colour by increasing the blue.

Tubes of black, white and grey give you a strict monochromatic scale, which you can use effectively in your painting to

▲ *The bands of neutral colour in the top two rows are mixed using broadly complementary colour pairs, showing the range achieved by varying the proportions of each colour and also adding white. The bottom row shows two blacks and Payne's Grey tinted with Titanium White. Blacks vary slightly, although the difference is difficult to gauge: Mars Black seems warmer than Ivory Black.*

enhance the colour biases of neutrals mixed from hues. Each kind of black gives a slightly different kind of grey when mixed with white. Payne's Grey is a very useful colour – straight from the tube it is a deep blue-black, and it makes excellent blued mid-tones and light tints when white is added. It also modifies bright colours more subtly than a straight black.

Earth colours, because they are somewhat muted colours, are good mixers for neutrals if you have them in your basic palette. Yellow Ochre, Raw Sienna and Burnt Sienna act as low-toned yellows and reds, giving warmth to colour mixes.

In summary, then, you can create many rich neutral shades with only red, yellow, blue and white, using the principles of secondary and complementary mixing. The greater the range of your palette – including, for example, tube greens and purples, different types of blue, and earth colours – the more variations you can achieve. Some more of these appear on the charts for the different media's starter palettes (see pages 28–33), shown in simple two- and three-colour mixes.

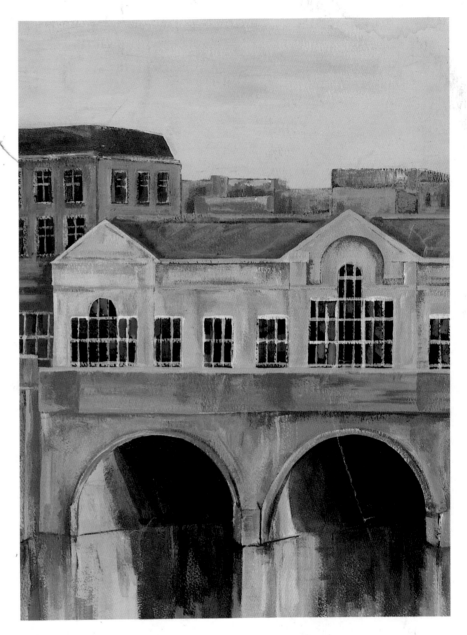

TECHNIQUES

The kinds of materials and environments that contain a lot of neutral colours often also contain variable textures – like the roughness that comes from weathering of stone or rock. Techniques such as spattering, dry brushing and broken colour effects (see pages 20–3) are particularly good for developing the colour relationships in textured materials and have a

more realistic effect than flat colour areas. There is a natural harmony between neutral colours, where there is no strong hue or tone that becomes obviously dominant, so you can make use of active brushwork and freely painted surface effects to enliven your painting without losing sight of the basic structure.

▲ *This is a subject that requires some subtle variation of colour to enliven the greyed cast of the urban environment. I have used the mixtures shown opposite in different areas of the picture, and also earth colours mixed with Payne's Grey and white. The greyish sky colour is Ultramarine and white tinted with Burnt Sienna. Using heavy-grained watercolour paper and dry brushed acrylic paint produced a rough-textured quality suited to describing stone surfaces.*
Palette: Crimson, Monastial Green, Ultramarine, Burnt Sienna, Yellow Ochre, Deep Violet, Payne's Grey, Titanium White

KEEPING COLOURS BRIGHT

Some subjects lend themselves to subtle treatment in muted colours, but many benefit from a lively, bold approach to using colour. Follow simple principles that will help you to keep your paintings colourful and fresh.

● Pay attention to the relationships of the colours you intend to mix. Are they like or unlike colours, so will they make a clean intermediary hue or a neutralized combination? Is the mixer colour going to add the right kind of bias to the hue you are adding it to?

▲ *The brilliant flower colours form a harmonious sequence relating to the red-purple sections of the colour wheel, with the green stems and foliage providing a fresh counterpoint to the warm colours. Notice that I have included the natural reddish shading on the flower stems, which creates a direct visual link between the complementary elements of red and green.*

Palette: Vermilion, Crimson, Deep Violet, Bright Green, Ultramarine
Payne's Grey, Titanium White

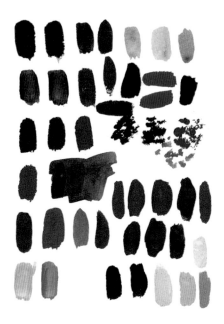

◀ *To obtain the rich colouring of the magenta flowers, I have first constructed a strong tonal underpainting in opaque colour (left). Because acrylics dry quickly, I was able to add the crimson glaze almost immediately, flooded across the whole shape, and when that dried, I put in the stippled detail of the dark flower centre (right).*

● Avoid overmixing. Ideally, you can find something very like the colour you are looking for using no more than two or three components in your mix. Adding more and more colours in the hope of 'turning' the mixture back to what you wanted is counter-productive – lots of colours blended together invariably make a muddy colour.

● Use your palette of colours appropriately. Don't waste time trying to make your paint colours behave quite differently from their natural character. Consider adjusting the key of your painting to incorporate the mixed colours you can easily obtain, or try exploiting surface mixing techniques.

VARYING YOUR TECHNIQUE

If there is a colour in your subject that you cannot match by mixing your paints, there are two ways of dealing with it. The first is to use a substitute colour, which might be one that comes from the same family of colours – a different kind of red, for example – or which may be a distinctly different hue – blue instead of purple, say – but one that will work well visually in relation to other colours in the subject.

The alternative is to consider whether you can apply a different technical approach, rather than trying to pre-mix the colour on the palette. The painting of anemones (opposite) is an example of when a particular challenge like this might come up. Flower colours are often intensely bright and vivid – they have a luminosity that can be difficult to match with the solid substance of paint.

With the range of colours that I was using I was unable to achieve any kind of mixed colour that corresponded to the richness of the deep magenta pink flowers. All the mixtures that I tried were dull or chalky by comparison with the real thing.

If there had been a true magenta in my paint range, I would have used it. But in this case, I had to find another solution. I made my available colours work more effectively by creating a tonal underpainting over which I put a glaze of unmixed crimson (see above).

Stippling, spattering and dry brushing techniques may also produce a more vibrant effect than an area of flat, pre-mixed colour (see pages 20–23).

▲ *I kept this chart of small colour swatches both to estimate the effectiveness of individual mixes and to see the colours in relation to each other before applying them to the painting. The third row shows the dull pinks I mixed while trying to make the magenta, before I decided on the glazing solution.*

▲ *In this subject, the natural world presents a perfect example of true complementary contrast. The very strong contrast of pure hues is nicely softened by the muted, neutralized shades of both red and green that also occur in the begonia leaves. These were achieved by mixing the colours in varying proportions, adding white to lighten them where necessary. Using a tightly restricted palette of oil colours, the only effect I could not match exactly was a warmer crimson tinge in some of the red leaves, but the darker brownish-reds provide a similar tonal balance.*

Palette: Cadmium Red, Burnt Sienna, Cadmium Yellow, Viridian, French Ultramarine, Titanium White

USING COLOUR CONTRAST

Another important attribute of colour is that the visual sensations of colours are influenced by each other, and you can enhance their appearance by the way you juxtapose them in your paintings. The basic elements of colour studied in the opening pages of this book – related and complementary hues, the range of tonal values, and the warm/cool effects we attribute to colours – provide various degrees of harmony and contrast that you can use to advantage in planning and carrying out your picture.

Complementary contrast is a powerful, even dramatic force in creating bold, bright colour effects. You will find various examples of it in natural forms – the red/green partnership is very strong in a wide range of plants, either in coloured foliages or in the combination of flowers and leaves. Designers as well as painters apply basic principles of colour interaction to make their work colourful and decorative, so you will see complementary contrasts used in all kinds of clothing and furnishing textiles, ceramics and paper goods. You can also set up a still life of natural or manufactured objects in a way that makes their individual colours form a striking grouped arrangement.

COLOUR INTERACTIONS

In your painting, you can orchestrate lively colour effects by picking up on the range of harmony and contrast that you see in the given colours of the subject. For instance, you can: choose to play up small accents of opposite colour that provide a counterpoint to a harmonious range of related colours; exploit a direct clash of complementaries; create dramatic impact by playing off contrasting colours and tones, even in a limited range; balance fully saturated, intense hues with subtly muted colours.

It is important to realize that a colour mixed satisfactorily on your palette may appear slightly different when given its position and context in your painting. This doesn't mean that it is not worth trying to mix accurately in the first place, only that you should eventually be spending more time with the colours on your paper or canvas than on the palette, because that is where their effects will be properly seen. This sometimes means feeling free to make adjustments as to how the colours work within the picture, independently of how they appear to work in the subject itself.

▲ This is an example of a colour exercise I set myself from time to time, to concentrate on accurate analysis of colour values. I make a still life of brightly patterned plates and 'copy' the designs abstractly, looking for a correct balance of hue and tone in the colour variations. The painting measures 52 × 59 cm (20½ × 23 in), so all the shapes are much larger than life size.

51

FOLIAGE AND GRASS

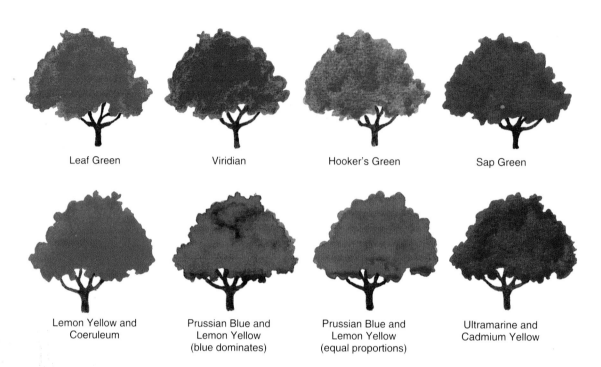

Leaf Green	Viridian	Hooker's Green	Sap Green

Lemon Yellow and Coeruleum	Prussian Blue and Lemon Yellow (blue dominates)	Prussian Blue and Lemon Yellow (equal proportions)	Ultramarine and Cadmium Yellow

If you are interested in landscape work, greens will naturally be a vital feature of your palette. The sort of questions you encounter here are basic ones about your range of paints and techniques – do you need tube greens in your stock of colours, and if so, which – how do you handle the variety of colour and texture in leaves and grass, keep colours fresh, and suggest a quality of light as well as local colour in the landscape?

TUBE COLOURS AND MIXED GREENS

Usually an introductory set of paints includes one green – most commonly Viridian, although in the acrylic palette it is Brilliant

Green (see pages 28–33). Viridian is a very rich, deep blue-green, not particularly typical of greens in nature. However, it gives you a starting point for a wide range of mixtures, with very different effects according to whether you add blue, yellow, red, brown or white, or any combination of such additional colours. The acrylic Brilliant Green is a strong, artificial-looking yellow-green, which also gives you a base colour for mixing to obtain darker tones and pure or neutralized hues.

If you are mixing greens from blue and yellow, the character of the colours you can achieve is basically fixed by the type of yellow and blue you begin with. Ultramarine and Cadmium Yellow, for example, produce a

▲ *This chart shows four watercolour greens taken direct from the tube (top row), with equivalent colours made from blues and yellows. The mixed greens are less bright and intense than the tube colours, except for Sap Green which is already subtly muted. Greens in nature are also typically more subtle than the tube colours, so these do need to be mixed and modified when you use them for landscape work.*

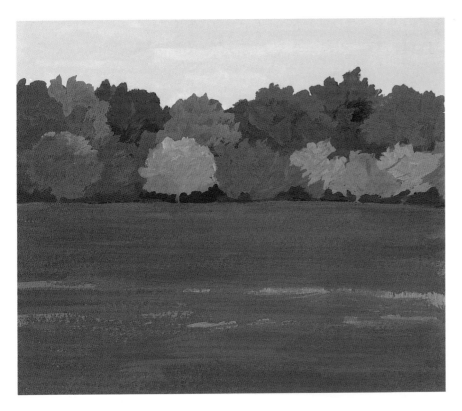

◀ *This gouache study is based on Viridian mixed with only four other colours. The broad impression of different kinds of trees massed together is described as patches of varying hues and tones.*
Palette: Viridian, Ultramarine, Spectrum Yellow, Burnt Sienna, Titanium White

▼ *The blue-greens and yellow-greens in this acrylic study are based on Hooker's Green and Monestial Green. As well as pre-mixing colours, I have brushed in small accents of pure yellow and blue in the tree on the left, orange and crimson on the right. Broken colours help to enliven the dominant spread of the greens.*
Palette: Hooker's Green, Monestial Green, Ultramarine, Cobalt Blue, Lemon Yellow, Brilliant Yellow, Yellow Ochre, Crimson

deep, yellowish green similar to Sap Green, while Prussian Blue and Lemon Yellow provide you with a mixture similar to Viridian or Hooker's Green, the mid-toned blue-greens.

MASSED AND BROKEN COLOUR

In any landscape there is a great variety of colour detail in individual forms and the patterns of light and shadow. You do not have to include all that detail to gain a naturalistic impression of your subject, but you need to key your palette to a representative range of hues and tones.

The more space and distance covered by your viewpoint, the less detail you can actually see. A stand of trees some distance away may appear as fairly solid masses of colour. When you are observing something closer, you will see more colour variations relating to the shapes and

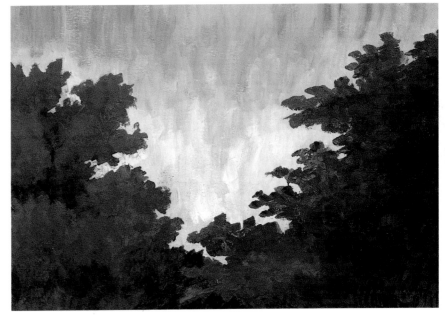

textures of branches and leaves. Broad areas of flat colour rarely work well in a painting, however, even where they are intended to create an impression of vast space. Most artists use techniques of creating broken or roughly blended colours (see pages 20–23) to give surface interest to the picture, and also to suggest the

textures of foliage and grass. Such techniques can be applied to a range of greens, or to shades of green interspersed with other pure hues. You can incorporate bold colour accents – touches of pure red or blue, for example – among dominant greens that contribute a broad impression of local colour.

ATMOSPHERIC SKIES

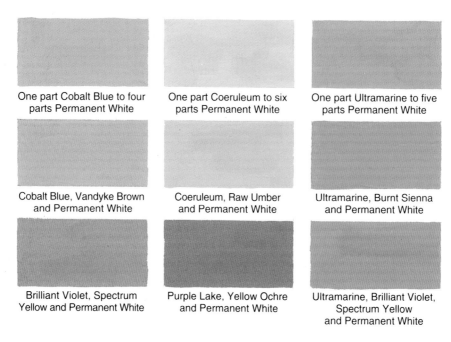

One part Cobalt Blue to four parts Permanent White

One part Coeruleum to six parts Permanent White

One part Ultramarine to five parts Permanent White

Cobalt Blue, Vandyke Brown and Permanent White

Coeruleum, Raw Umber and Permanent White

Ultramarine, Burnt Sienna and Permanent White

Brilliant Violet, Spectrum Yellow and Permanent White

Purple Lake, Yellow Ochre and Permanent White

Ultramarine, Brilliant Violet, Spectrum Yellow and Permanent White

Everyone has a strong awareness of the colour of the sky, because seasons and weather patterns affect the ways we live our lives. For the artist, sky colours are a perennial fascination.

Bear in mind the difference between matching the colour that you see and keying the hues and tones to create the right qualities for your painting (see pages 26–7). In a landscape or townscape, the sky is an important indicator of the mood of the painting, and it may be appropriate to lighten or darken it in relation to the other colours.

COLOUR VARIATIONS

Firstly, keep it simple, especially if the sky is essentially acting as a background to the detail of your subject. For a clear, blue sky, choose a blue from your palette to make a light-toned tint. Cobalt Blue has a strong, fresh effect that makes a good foil for sunny landscape colours. Coeruleum is slightly cooler and Ultramarine is warmer – these properties may help you suggest a clear sky with weak sun, or a heavy atmospheric sky above a city.

Blues neutralized with subtly complementary mixers, such as Burnt Sienna or Raw Umber, make more naturalistic greys than simple black and white.

Certain times of day and weather conditions produce unexpected colour casts in the sky, which can be exaggerated to enhance the sense of mood and location, provided that the other colours are carefully keyed to this influential part of the composition.

▲ *Blues straight from the tube mixed with white can make quite satisfactory sky colours. For the heavy shades of overcast or stormy skies, introduce purples, browns and yellows. These examples are gouache colours; you will find exact equivalents or very similar colours in oil and acrylic ranges.*

▲ *Over a basic mix of Ultramarine and white, made lighter at the horizon of the picture, the clouds were painted by rolling a round-haired brush loaded with opaque white. This produces slight variations of tone and texture that model the shapes softly. In a bright sky, clouds should seem buoyant and lightweight.*

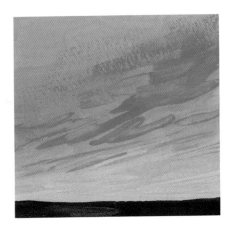

▲ *The brownish and purple mixtures shown above were lightly blended and gradated with rapid, fine brushstrokes to create this heavy storm-cloud effect. Again, the lightest tones appear at the horizon, but the thundercloud appears to hang low over the land.*

VARIEGATED COLOURS

Often the problem with painting skies is not strictly one of finding the right colours, but of varying the colour nuances subtly to suggest effects of light. When you mix colours on the surface, avoid creating hard-edged bands of colour and cloud shapes that would make the sky look solid.

Watercolour washes can be brushed together while still moist, or dampened with clean water to lift out excess colour. Oil paints stay moist so you can rework colour blends and 'feather' the edges of shapes with light brush strokes to soften them. Acrylics and gouache are more of a problem because the paint dries quickly. While mixing on your palette, the colour on the paper has dried, and you will need to overpaint. You may need to rework the colour in order to brush in a new shade.

▼ *With watercolour washes, it is more effective to brush colours into one another on the paper, than to mix them on the palette.*

▲ *Blotting is a simple technique for putting fluffy, pale clouds into a watercolour sky. Make the colour wash very wet, then take a tissue and blot the paint to lift out the shapes of* the clouds. Add subtle tints of other colours to vary the lighting, but be careful not to overwork the washes or the colours may mix and become muddy.

SHADOWS

S hadows often appear to be an absence of colour and light, but they can be treated quite colourfully in paintings. Solid black shadows are only really appropriate if colours are very low key or there is a restricted, high-contrast tonal range in the picture, like the dramatic chiaroscuro (light/dark) scenes painted by the Italian artist Caravaggio (1571–1610).

SHADING AND SHADOW

Shadows are of different kinds and serve different functions in picture-making. Any attempt to model form in a realistic manner immediately requires you to deal with shadow areas – whether subtle shading that shapes an object, or the shadowed background that throws your subject into relief. This shadowing can be quite softly formed and contain variations of mid- and dark tones. The tones and hues in the shadows may also relate directly to the local colours underlying the patterns of light and shade (see pages 24–5).

Cast shadows are formed by an object or figure blocking the path of light, so that a silhouette, full or distorted, is cast on to the ground or background planes of the environment which the subject occupies. The shape and direction of the shadow helps to anchor the positive forms in relation to their surroundings.

Cast shadows are often solidly shaded, hard-edged and very dark.

COLOUR IN SHADOW

There are two colour components of shadow – the tone and the bias towards a hue. Cool colours work well as shadow colours – deep blues, purples and greens. Where shadows indicate deep space, like

▲ *In this watercolour study the market stall made an attractive contrast to the bright-coloured goods on display and the cavern-like interior, heavily shaded because the sun was strong outside. I used warm and cool variations throughout, both to create the deep space and to model form and cast shadows.*
Palette: Vermilion, Lemon Yellow, Coeruleum, Viridian, Ultramarine, Burnt Sienna, Mauve

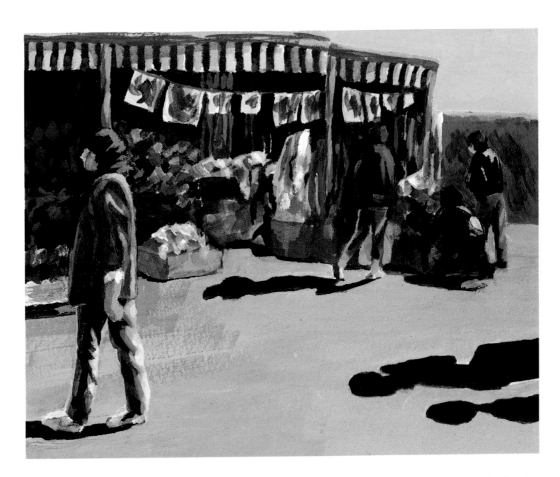

recesses and folds in solid objects, they can appear relatively warm, because the warm colour is inviting and draws the eye into it. Here you can consider using the deep browns and earth colours, or red-purple shades.

A very dark, neutral shadow may be aptly represented by using black. But you might also try the effect of the rich, blue-black Payne's Grey. This gives a very dark tone for the lower end of your tonal range, but is less stark than true black. Another possibility is to tint a true black with bright hues (see pages 42–3).

Reflected colour can cut into a shadow, making a surprisingly bright accent within the overall dark tone. This depends on the tone and texture of your subject – how responsive it is to incidental light – and on the strength of the colours in its surroundings (see pages 25 and 58–9).

▲ *In this broader view, I decided to use the cast shadows somewhat abstractly, to make a strong pattern of shapes. They are irregularly contoured, but the outlines of the shapes are deliberately made hard-edged, and the tone high in contrast. As I was using opaque acrylic paint, I was able to adjust the balance of tones continuously by overpainting.*

Palette: Cadmium Red, Cadmium Yellow, Monastial Green, Ultramarine, Red Violet, Burnt Sienna, Payne's Grey, Titanium White

▼ *The purple shadow is much softer than the grey, but effective both as a dark tone and as a link to the colour scheme of the figure's clothing. Complementary touches of Cadmium Yellow warm the strongest highlights on the figure, and the folds in the clothing are heavily modelled.*

REFLECTIVE SURFACES

Because metal and glass are such highly reflective materials, one of their most noticeable qualities is a high degree of tonal contrast. Highlights and shadows can be equally intense and sometimes dramatically opposed within a relatively small area. It is important to deal with these boldly, as the impression of 'shininess' is lost if the modelling is too soft.

Both materials also display a lot of reflected colour, but differently distributed. Particular kinds of metals do have distinctive colours of their own – think for example, of the obvious difference between silver and copper, the more subtle difference between gold and brass. But the local colour may be only a small proportion of the surface colour of a metal object, among a pattern of highlights, shadows and reflected colours. Glass is a different proposition because it is translucent. You therefore see both reflected and transmitted colour from the surrounding objects and surfaces.

▲ *These clear plastic salt-and-pepper grinders have no distinct colour, so I have interpreted the tonal patterns as a variation between warm and cool neutral colours and greys, with small touches of reflected colour. It is the combination of shapes and tones that achieves both the reflective effect and the translucency. I have used opaque gouache, to be able to work light over dark, and a relatively limited colour range.*
Palette: Lamp Black, Permanent White, Cadmium Red, Vandyke Brown, Yellow Ochre, Spectrum Yellow, Ultramarine, Coeruleum

SEEING A PATTERN

There is no convenient short-cut to a convincing rendering of glass or metal. You do have to study it intensively, to decipher the complex pattern of shapes and colours. Some will be very clearly defined, others shading more subtly into one another.

Looking at this pattern, decide which of the colour elements are essential to the description. Almost invariably you should simplify the problem somewhat by being selective – particularly as the surface effect will change with any change in the surrounding light level, or in your own viewpoint.

COLOUR VARIATIONS

When working out what colours to apply, try to ignore what you know about the subject and deal only with what you see. With metals, for instance, you may find that what you perceive as the local colour looks very dull on your palette – a slightly yellowish grey for silver, perhaps, or a dull, dirty yellow for brass. This may seem wrong, because you think of the metal as being bright and reflective. But it is the variations of colour and tone juxtaposed with this 'base colour' that will produce the required effect.

Similarly, you may find it difficult to believe that you see a very pure, strong hue as reflected colour on glass or metal – say, turquoise blue or brilliant scarlet. However, if the object is adjacent to something that does have that colour, you may well be seeing a very pure flash of it reflected. Making a bold, definite colour statement is often the key to success.

MIRROR REFLECTIONS

A mirror image is different because the glass is manufactured to produce a true reflection. You see a picture, not a pattern.

The conventional way of treating a mirror image in painting is to make it slightly less intense than the visible subject – subdue the contrasts, play down extreme highlights and bright hues, even make the shapes less well defined. Also, watch how things appear differently angled in the mirror view.

▲ *The aim of this still life was to discover a visual difference between the colour qualities of the real objects and their reflections. In front, the metals pick up rich, warm tones from the brown velvet beneath them and direct dazzle from the nearby lamp. On the back reflected in the mirror, the colours are cooler and the lights less intense, because they reflect back from the mirror, rather than beaming directly from the light source.*
Palette: Payne's Grey, Yellow Ochre, Raw Umber, Burnt Sienna, Cadmium Orange, Lemon Yellow, Titanium White, Ultramarine

COLOURS IN WATER

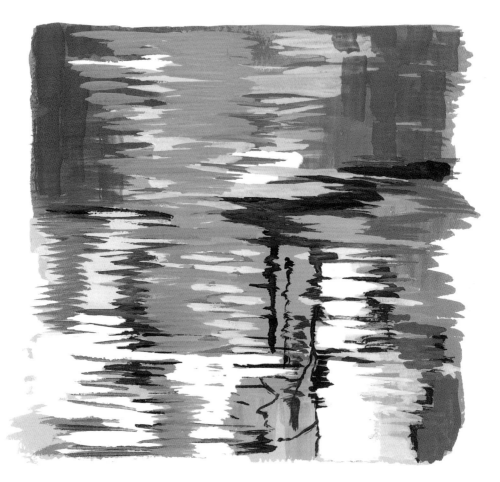

The complex subject of water combines the characteristics of transparent and reflective materials, with the additional complication in many cases that the pattern of shapes and colours is constantly moving and changing.

Water has the mirror-like property of reflecting its surroundings in some detail; if there is movement on or below the surface of the water, the 'picture' breaks up and distorts. As with glass, study the individual shapes and their hues and tones, and build up your painting piece by piece. Occasionally you see a very clear, intense and complete reflection; at other times it is more fluid, less well-defined or even heavily distorted.

As with a mirror reflection, you may find it effective to make the reflected colours a little less vivid than the colours of the objects they are reflecting. You can also formalize and simplify the pattern of shapes in, say, the rippling movement of a river or pool.

▲ *Water in a landscape reflects the colours of its surroundings and of the sky. The surface of a river can seem quite still, but undercurrents create ripples which distort reflected shapes, and form intricate patterns in a variety of hues and subtle, neutral colours. Try to obtain the correct tonal balance between mid-toned colours and light-dark contrasts.*
Palette: Spectrum Yellow, Cadmium Red, Ultramarine, Vandyke Brown, Permanent White

MOVING WATER

The sea is a difficult subject, but there are two key elements to rendering the vigorous movement of the waves. One is to get the balance of tones correct – the underside of a wave crest is very dark as compared to the white foam, for example. This tonal pattern is more important than precise colour matching, as you can work with any of a wide range of blues, greens and greys. Often the sea is composed of muted and subtle colours rather than strong hues, but it sometimes appears very colourful in itself, and the water surface may show brilliant flashes or broad patches of reflected light.

The second important factor in conveying moving water is to keep your brushwork free and active. You can use loose washes and glazes, building up veils of overlaid colours, and feather or roll opaque colour on to the surface with quick strokes of the brush. Use bold gestures and incorporate raw edge qualities and irregular textures, otherwise the shapes of the waves appear too solid and the movement is arrested.

▲ *When you are using an opaque medium, work the main tonal pattern from dark to light. You can apply modifications and finer detail by overpainting, leaving the strongest highlights until last. Here I have built up dark and mid-tones with washes of acrylic paint, then added texture with dry brushing and feathered brush strokes in opaque white to create ripples and foam.*
Palette: Payne's Grey, Ultramarine, Lemon Yellow, Titanium White,

FLESH TINTS

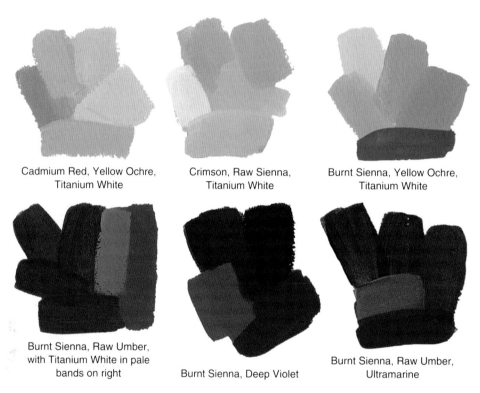

Cadmium Red, Yellow Ochre,
Titanium White

Crimson, Raw Sienna,
Titanium White

Burnt Sienna, Yellow Ochre,
Titanium White

Burnt Sienna, Raw Umber,
with Titanium White in pale
bands on right

Burnt Sienna, Deep Violet

Burnt Sienna, Raw Umber,
Ultramarine

There are at least as many skin tones as there are people, so it is impossible to rely on formulae for mixed colours. Your approach to painting flesh tints will also depend on the type of rendering you wish to produce. For example, a rapid watercolour study can work excellently in only three or four colours, whereas in a detailed oil or acrylic portrait, you may find yourself mixing a great variety of subtle hues and tones.

COLOUR QUALITIES

Skin colours, light and dark, have natural warmth and slight luminosity. For basic flesh tints, the earth colours such as ochres, siennas and umbers often make better mixing colours than the brilliant, artificial pigments such as Cadmium Red and Yellow. However, you may also see some very clear, high-toned tints for which you would need the brighter range.

The colour of the light and pattern of light and shadow on a face or figure greatly influences the colour qualities of the skin, and the range of both hues and tones can change dramatically within a small area of the subject. Some artists deal with this using the technique of broken colour, adding small dabs and patches of colour that gradually mesh into a distinct impression of form.

▲ *The classic basic recipe for light flesh tints is red, yellow and white. The earthy tones of Yellow Ochre or Raw Sienna make subtler, richer tints than the bright yellows. For dark skins, earth colours also form the basic ingredients – Burnt Sienna and Raw Umber provide a natural contrast of warm and cool dark tones, and it is not typically necessary to add white, unless to give opacity. These are random examples of suitable mixes; there could be many more, different combinations.*

▲ *The cool cast of winter daylight contrasts with the natural warmth of flesh colours. Naples Yellow provided a good basis for mixing the pale tones of the lit areas, with more Cadmium Red added where the skin showed warm pink tints. Because of the cold quality of light, there were distinct greenish tints in the shadows.*
Palette: Naples Yellow, Cadmium Red, French Ultramarine, Burnt Sienna, Viridian, Flake White

▶ *The oil study above right worked well with a very restricted palette. Lamplight brought up the warm tones of the skin, which made the rich pink Flesh Tint a suitable base colour for mixing. I used French Ultramarine both to darken and neutralize the shadow colours.*
Palette: Flesh Tint, Flake White, Yellow Ochre, French Ultramarine

Others look for broader colour changes and, having defined an overall pattern, look for colour accents and reflected lights that enliven the basic tones.

CHOOSING A PALETTE

Most artists develop a personalized palette relating to their preferred subjects and the colours they find most useful for mixing. Naples Yellow is often recommended for pale skin tones. It is a light, opaque yellow that can be variable between different media, sometimes appearing quite pinkish and very warm, in other forms tending to a cooler basic tint.

I found this useful for a daylight colour study when the cold natural light bleached out the most brightly lit parts of the face. It is possible to mix a colour similar to Naples Yellow, but having a tube saves time and means you use up less white (it is also a valuable colour for a landscape or townscape palette, mixing well with greens or neutrals). However, it is available

only in the Daler-Rowney oil and watercolour ranges, not as acrylic or gouache.

The other obvious possibility to explore was the colour actually called Flesh Tint, available in oil and acrylic. It is quite a strong, deep, yellow-tinged pink – used straight from the tube as your basic tint, it would give you too dark a key for the portrait. Like Naples Yellow, it is a useful base for mixing, but it needs to be modified to both darker and lighter tones as you work, and its colour quality can be varied with the addition of pure hues.

▲ *Dark skin is very responsive to the quality and direction of light. The glossy texture of acrylic paint helped to bring up the sheen on the skin, through distinct tonal modelling with Ultramarine and Deep Violet to enrich the browns. I have given an overall warm cast to the skin tones, using contrasts of glazed and opaque colour.*
Palette: Burnt Sienna, Raw Umber, Deep Violet, Ultramarine, Lemon Yellow, Titanium White

WORKING WITH YOUR MEDIUM

If you use an opaque medium like oil, or one which builds up opaquely like acrylic, you can vary pale tints by adding white as necessary, and you can also overpaint to correct and adjust individual areas of the painting as you go along. With watercolour, you need to take a more subtle approach and avoid applying too much colour. If you cannot rework pale tones, you must conserve light areas from the start, to maintain the skin's luminosity.

Your approach to colour mixing will be different with watercolour, and may also be simplified. Because you can build up the colours in thin, diluted washes, gradually strengthening tones and colour contrasts, you may find that less mixing is required. Well-diluted Vermilion, for example, makes a good pinkish flesh tint without the addition of any other colour. Raw Umber, a cool, dark brown, is useful for the heaviest shadows and can be tinged with blue or purple for warmer shading and lightly cast shadow. Variations of warm and cool colours are a useful key to modelling skin tones. In the lit areas, you may see a strong effect of warmer colours, with brighter red and yellow tints. As you gradually overlay the watercolour washes, subtle modifications naturally occur that correspond to the complex and sometimes elusive qualities of flesh tints.

▲ *As an exercise in broken colour, try working a self-portrait in this way, using distinct brush strokes to note every change of colour with strong emphasis. Gradually, the portrait will become very detailed and characterful, if not strictly naturalistic. This is good for training your eyes to pick up colour variations.*

▲ *One of the problems with painting skin tones is that across subtly curved areas of the face, like the brow and cheek, it is often difficult to identify definite colour variations that help to describe the form. In this gouache study, I decided to treat even small colour changes very boldly, putting down individual hues and tones with deliberate, separate brushmarks. This approach builds gradually towards a striking portrait with well-defined modelling of the facial structure.*

◀ *The liveliness of this watercolour study comes from the small touches of white showing highlights on the knuckles, fingernails and wrist. The sequence of work was to paint the main shadows first in Raw Umber, wash in the secondary shadows with a mix of Raw Umber and Mauve; then develop the lit tints in successive, thin layers of the brighter hues.*
Palette: Raw Umber, Mauve, Vermilion, Burnt Sienna, Crimson Alizarin, Cadmium Yellow